Mastering MANGA 2

Level Up With Mark Crilley

IMPACT
CINCINNATI, OHIO
www.impact-books.com

Contents

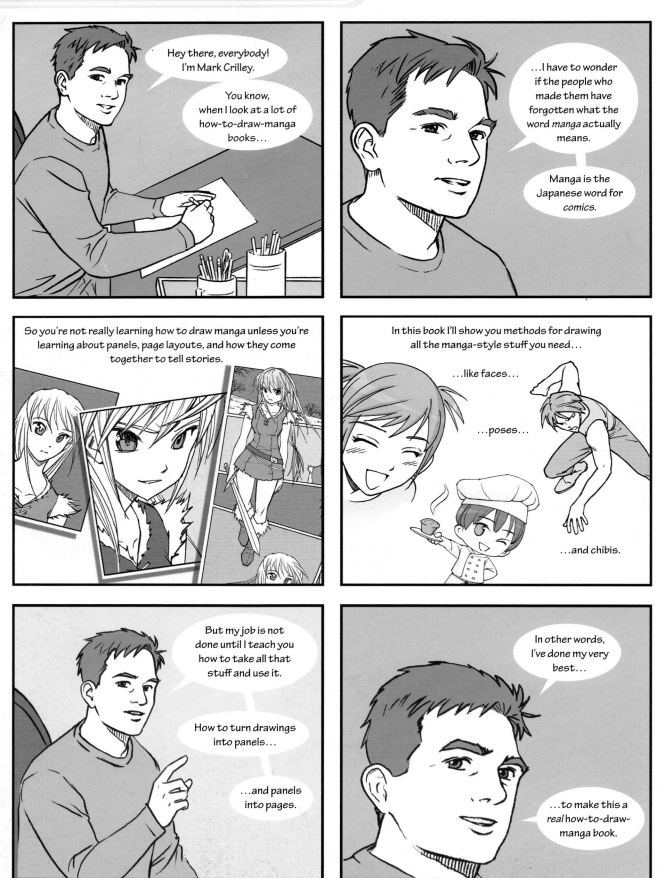

Hey there, everybody! I'm Mark Crilley.

You know, when I look at a lot of how-to-draw-manga books…

…I have to wonder if the people who made them have forgotten what the word *manga* actually means.

Manga is the Japanese word for comics.

So you're not really learning how to draw manga unless you're learning about panels, page layouts, and how they come together to tell stories.

In this book I'll show you methods for drawing all the manga-style stuff you need…

…like faces…

…poses…

…and chibis.

But my job is not done until I teach you how to take all that stuff and use it.

How to turn drawings into panels…

…and panels into pages.

In other words, I've done my very best…

…to make this a *real* how-to-draw-manga book.

What You Need

Many aspiring artists tend to worry a little too much about art supplies. There seems to be a belief that having all the right stuff is the key to creating great art. Well, that's like thinking that if you just wear the right swimsuit, you'll be able to swim as fast as Olympic gold medalists do.

What really matters is not the pencil, but the brain of the person holding it. Experiment to find the sizes, styles and brands of art supplies that work best for you.

Paper

I almost want to cry when I see that somebody has put hours and hours of work into a drawing on a piece of loose-leaf notebook paper. Do yourself a favor and buy a pad of smooth bristol paper. It's thick and sturdy, and will hold up to repeated erasing.

Pencils

Pencils come down to personal preference. What is perfect for me may be too hard or too soft for you. I like a simple no. 2 pencil—the kind most of us grew up with. But there are pencils available in varying degrees of hardness and quality. Try some different types of pencils out to test the marks they make. It is important to remember that the softer the lead is, the more it may smear.

Pens

Get a good permanent-ink pen, one that won't fade or bleed over time. They are available in art stores. Don't confine yourself to super-fine tips. Have a variety of pens with different tip widths for the various lines you need.

Rulers

Get yourself a nice, clear plastic ruler so that you can see your art as you make lines. A 15-inch (38cm) is good, even for some of the longest lines.

Kneaded Erasers

These big soft erasers, available in art stores, are great for erasing huge areas without leaving tons of pink dust behind. However, they aren't always precise, so feel free to use them in combination with a regular pencil eraser.

Pencil Sharpeners

I've come to prefer a simple hand-held disposable sharpener. You'll get the best use out of it while the blade is perfectly sharp.

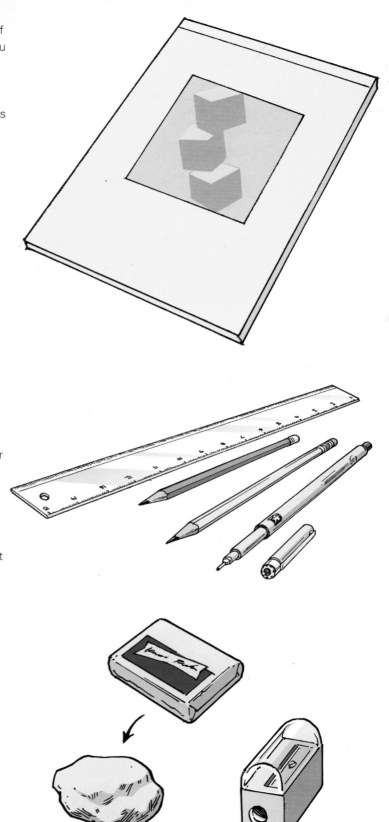

Making the Manga Eye

Let's get started with a little practice step-by-step demonstration. This will get you familiar with the process we'll be using throughout the book. I've decided to use a pair of manga eyes as the subject matter. Eyes are a great place to begin manga drawing as they are key to the characters, yet simple, even if you are an absolute beginner.

MATERIALS

bristol paper or bristol board

clear plastic ruler

kneaded eraser

pencil

pencil sharpener

pens in a variety of tip thicknesses

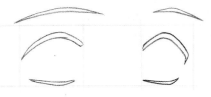

1 Draw two horizontal pencil lines about 1 inch (2.5cm) apart. Connect them with four vertical lines, each an equal distance apart. The three resulting shapes should be narrower than they are wide.

2 Draw the eyebrows and upper and lower eyelashes. Note the angle of each line and the curves—some are very gentle, others are more pronounced. Finally note the distance between the lines. Use the initial guidelines to help you see where all the various elements belong.

3 Add the iris of each eye, including oval shapes for highlights—a large oval at the top and a small one in the middle on the right side. The pupil of each eye in this style resembles a crescent moon.

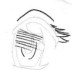

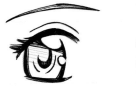

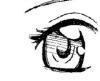

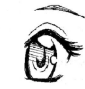

4 Begin adding details. Draw a line for the fold of the eyelid above each eye, eyelashes on the left and right edges of the upper eyelids, and some shading lines across each iris. Feel free to experiment with your own shading style if you like.

5 Put down the pencil and grab your ink pen of choice. If you were careful following steps 1 through 4, then you will know exactly where to put heavy black lines and which areas to leave blank.

6 Leave time for the ink to dry completely. (It may take several minutes depending on the brand of pen you're using.) Then carefully erase all the penciled guidelines.

Keep Your Pencil Lines Light!

The pencil lines in the step-by-step lessons of this book appear dark and bold for clarity, but keep them light in your own drawings. Pencil lines need to be erased after inking.

Anatomy of a Manga Panel

Every manga panel is composed of a wide variety of elements, each requiring different types of artistic knowledge. This book is designed to familiarize you with all of them.

The Head and Face

Every manga artist starts by learning that unique combination of facial features that is recognized the world over as "the manga style."

The Human Body

The next logical step in the process is gaining a good sense of body proportions. This is truly a life long process for any artist.

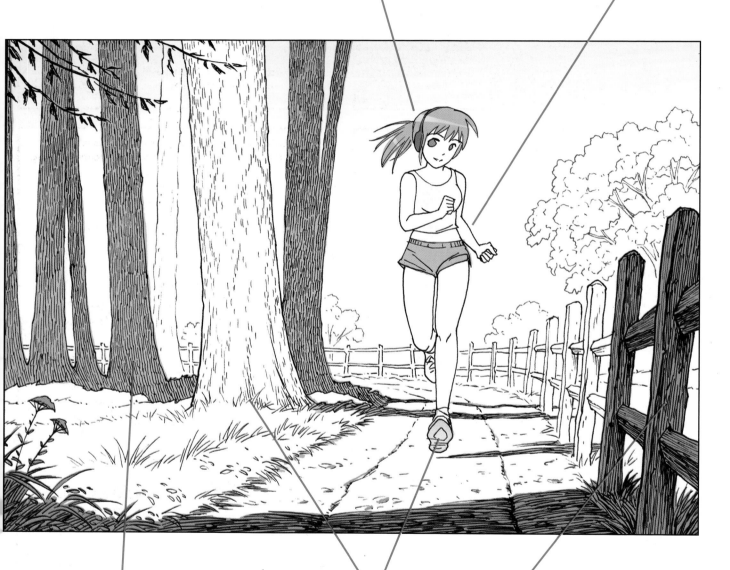

Backgrounds

This subject is often neglected by the beginner, but any professional will tell you that learning to draw various environments is every bit as important as learning how to draw your characters.

Composition

The components of a panel aren't just tossed in randomly. The artist carefully plans it all out to create an arrangement that is pleasing to the eye.

Conveying Depth

Artists use a variety of tricks to make two-dimensional images on the page appear three-dimensional, making some elements seem closer and others seem farther away.

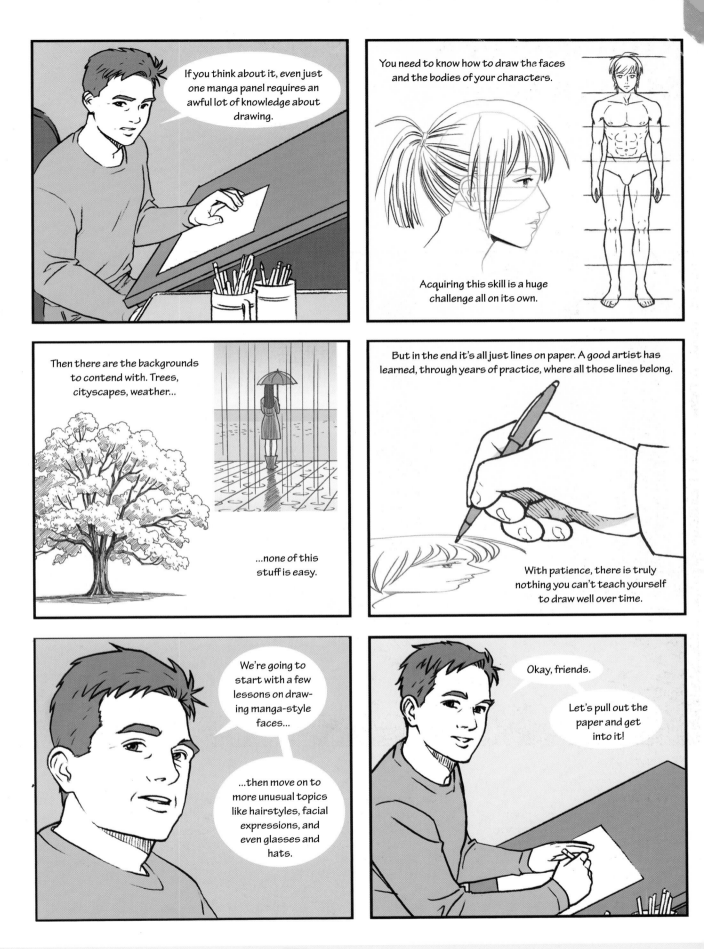

If you think about it, even just one manga panel requires an awful lot of knowledge about drawing.

You need to know how to draw the faces and the bodies of your characters.

Acquiring this skill is a huge challenge all on its own.

Then there are the backgrounds to contend with. Trees, cityscapes, weather...

...none of this stuff is easy.

But in the end it's all just lines on paper. A good artist has learned, through years of practice, where all those lines belong.

With patience, there is truly nothing you can't teach yourself to draw well over time.

We're going to start with a few lessons on drawing manga-style faces...

...then move on to more unusual topics like hairstyles, facial expressions, and even glasses and hats.

Okay, friends.

Let's pull out the paper and get into it!

Heads and Faces

The biggest distinction that sets Japanese comics apart from comics elsewhere is the way the faces are drawn. It's the natural place for an aspiring manga artist to start. Who wouldn't want to learn how to draw those shiny eyes and wild hairdos?

In this section we will learn the basic structure of manga faces and how to draw them from a variety of angles. There will be challenges along the way, but if you keep at it, you'll be drawing manga faces with the best of them!

Visit impact-books.com/masteringmanga2 to download a free bonus demonstration.

Female Front View

There is incredible variety in the way different manga artists draw faces. Any step-by-step lesson is by necessity teaching you just one approach. If you are serious about your craft, you will want to learn other ways over time.

I have chosen a style that is somewhat close to real human proportions while still being recognizable as "manga" in the way it emphasizes the eyes and de-emphasizes the nose and mouth.

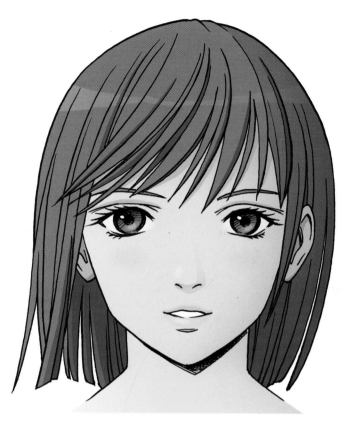

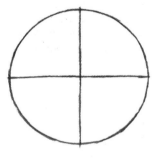

1 Draw Your Circle
Draw a rough circle neatly divided by a vertical line and a horizontal line. The vertical line is there to help you place the nose. The horizontal line will help you find the locations of guidelines for the eyebrows and eyes in the next step.

To get the three lines evenly spaced, draw the middle line first, dividing the space in half. Then draw the other two lines, dividing the space into quarters.

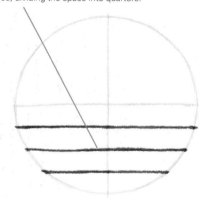

2 Mark the Feature Lines
Divide the lower half of the circle into four equal sections by adding three additional horizontal lines. The first of these three lines will help you place the eyebrows. The other two will help you place the eyes.

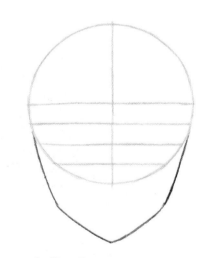

3 Outline the Jaw
Add lines for the jaw. Take care to get the size and shape of this area right. Focus on the angles of each line and the shape that is created between them and the circle. The distance between the bottom of the circle and the tip of the jaw is equal to three of the subsections you created in the previous step.

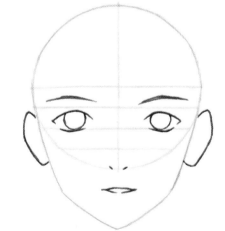

4 Place the Features
Add the eyes, eyebrows, nose and mouth. The eyebrows are between the top two horizontal lines. The eyes rest upon the third line. The nose is at the point where the vertical line meets the bottom of the circle. The mouth is slightly closer to the circle than it is to the chin.

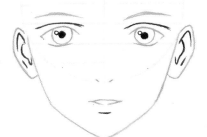

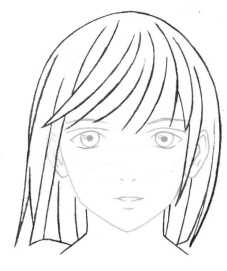

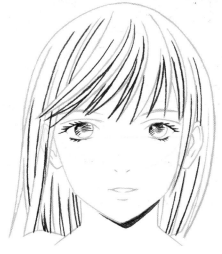

5 Draw the Ears and Eyes

Add the ears and details to the eyes. Note that the two lines above each eye indicate the fold of the upper eyelid. My style of drawing the ears here is fairly close to actual human anatomy, but feel free to simplify them if you prefer. The small circles in each iris will become white highlights, making the eyes look shiny.

6 Form the Hair and Neck

Add lines for the hair, the neck and the shoulders. There are hundreds of ways to draw manga hair. The upper line of the hair is drawn a fair distance above the circle. This contributes to the youthful look of the character. The width of the neck is such that it lines up with the irises above.

7 Fine-tune

Add an indication of shadow beneath the chin, as well as further details to the hair. Note that the hair lines curve to follow the shape of the head.

8 Finish It

Carefully ink all the lines you want to keep and erase the rough guidelines once the ink has dried. The finished drawing can be enhanced with grey tones or given the full color treatment.

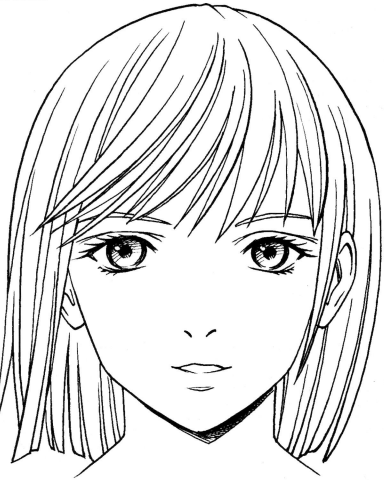

Female Profile View

Drawing a face in profile presents a number of challenges. The lips can be particularly difficult, and if the lines are off by even just a little, the expression will look unnatural. Remember that it's not only a matter of drawing the lines but replicating the distances between the lines. If you focus on how far the eyes are from the bridge of the nose and how far the lower lip is from the chin, you will be rewarded with a balanced and beautiful final result.

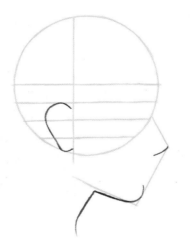

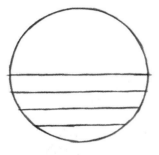

1 Draw Your Circle
Draw a rough circle neatly divided in half from top to bottom with a single horizontal line. Take the lower half of the circle and divide it into four sections, each of them equal in height from top to bottom. These lines will help you place the eyes and nose later on.

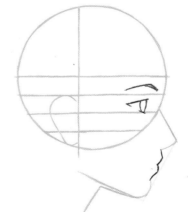

2 Outline the Nose and Jaw
Begin with a vertical line that is a touch left of center. Go slowly as you outline the nose and jaw, taking care to reproduce not just the lines, but their various angles and the shape of blank space that is formed between the lines and the edge of the circle. The line of the nose touches the circle just above the third horizontal line. The tip of the nose lies just below the fourth horizontal line.

3 Place the Ear, Nose, Chin and Neck
Add lines for the ear, bottom of the nose, chin and neck. The ear touches the vertical line, the second horizontal line, and the edge of the circle. The bottom of the nose meets the point of the nose at a 90° angle. The chin is curved. The line of the neck meets the line of the jaw about one-third of the way along the jawline we drew in the previous step.

4 Place the Eyes and Lips
The eyebrows are between the top two horizontal lines. The eye rests on the third horizontal line. Pay attention to the distance between the eyebrow and the edge of the circle. The lips are a gentle *W* shape. Note that the lower lip touches the guideline we drew in step 2, while the upper lip does not.

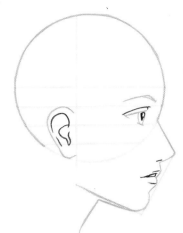
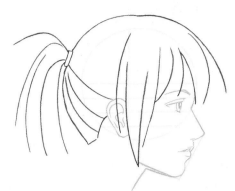
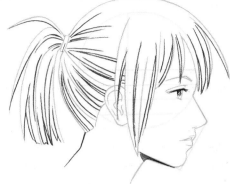

5 Add Details

Draw the interior lines of the ear. Use the horizontal lines to help you see where the lines belong. The fold of the upper eyelid touches the second horizontal line. The lines of the mouth and lips are a tiny distance from each other, but that distance is crucial. Pay attention to both the lengths of the lines and their angles.

6 Add the Hair

Sketch in a rough hairstyle with a few lines. I've chosen to give her a ponytail but feel free to choose any hairstyle you like.

7 Fine-tune

Add individual strands of hair, eyelashes and a shadow beneath the chin.

8 Finish It

Ink the drawing, taking care not to ink any of the early guidelines you needed only for line placement. Let it dry, then erase the pencil lines. The finished drawing can be left as is, enhanced with gray tones, or given the full color treatment.

Male Front View

It's amazing what a difference a few lines can make. If you compare the drawing of the female face with that of the male, you will see that the key differences come down to just two things: the eyelashes and the bridge of the nose. And yet that's all it takes. Artists have long understood the decisive power of a few lines added or subtracted in just the right places.

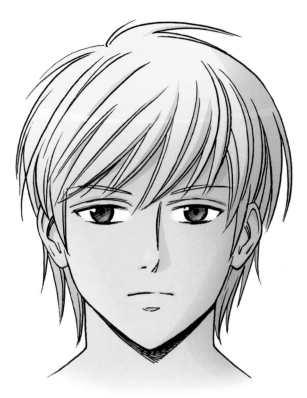

1 Draw Your Circle
Draw a rough circle, neatly divided by a vertical line and a horizontal line. The vertical line is there to help you place the nose. The horizontal line will help you find the locations of guidelines for the eyebrows and eyes in the next step.

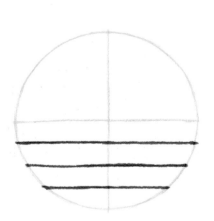

2 Mark the Feature Lines
Divide the lower half of the circle into four equal sections by adding three additional horizontal lines. The first of these three lines will help you place the eyebrows. The other two will help you place the eyes.

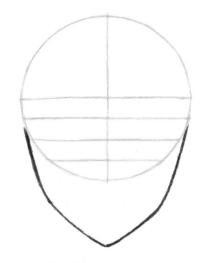

3 Outline the Jaw
Add lines for the jaw. Take care to get the size and shape of this area right. Focus on the angles of each line and the shape that is created between them and the circle. The distance between the bottom of the circle and the tip of the jaw is equal to three of the subsections you created in the previous step.

4 Place the Features
Add the eyes, eyebrows, nose, ears and mouth. The eyebrows are between the top two horizontal lines. The eyes rest upon the third line. The nose is at the point where the vertical line meets the bottom of the circle. The mouth is slightly closer to the circle than it is to the chin.

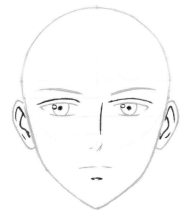
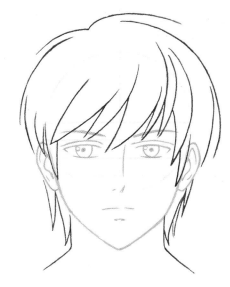
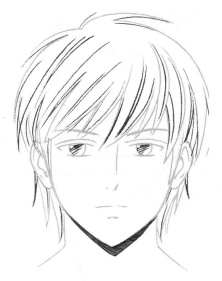

5 Draw the Ears and Eyes

Add the ears and details to the eyes. A simple vertical line defines the bridge of the nose. The two lines above each eye indicate the fold of the upper eyelid. My style of drawing the ears here is fairly close to actual human anatomy, but feel free to simplify them if you prefer. The small circles in each iris will become white highlights, making the eyes look shiny.

6 Add the Hair and Neckline

Add lines for the hair, the neck and the shoulders. The upper line of the hair is drawn a fair distance above the circle. This contributes to the youthful look of the character. The male character's neck is wider than that of the female: These lines point toward the far left and right hand edges of each eye above.

7 Fine-tune

Add an indication of shadow beneath the chin, shading to the eyes, as well as further details to the hair. Note that most of the hair lines curve to follow the shape of the head, while the small strands behind the ears curve away from the neck.

8 Finish It

Carefully ink all the lines you want to keep. Let the ink dry, then erase all the pencil lines. Leave as is, shade, or color.

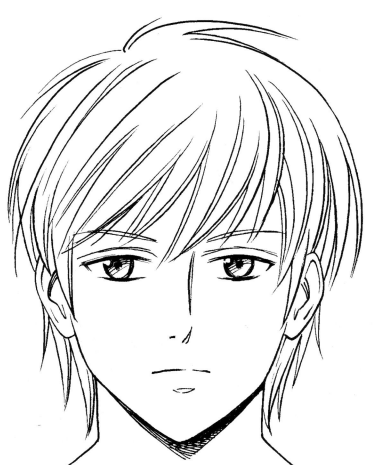

Male Three-Quarter View

The three-quarter view is arguably the most important one for a manga artist to learn as it is used most frequently in the storytelling process. Mastering it requires extra attention since placement of the facial features shifts in subtle ways to account for the structure of the head as it turns in space.

Manga stories tend to be dominated by characters that appear vaguely Caucasian. But you may want to present characters of various ethnicities in your stories, so for this lesson I've decided to break away from the "manga default" in that regard.

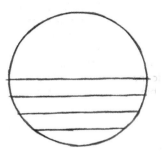

1 Draw Your Circle
Draw a rough circle, neatly divided in half from top to bottom with a single horizontal line. Then take the lower half of the circle and divide it into four sections, each of them equal in height from top to bottom. These lines will help you place the eyes and nose later on.

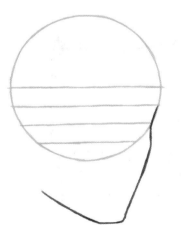

2 Outline the Cheek and Jaw
Begin with a line that follows the circle from the second horizontal line to the third horizontal line. Have the line leave the circle and travel vertically for a short distance, defining the cheekbone. Right around the fourth horizontal line, tilt the line diagonally until it reaches the chin, which is at an equivalent distance from the circle to three of the horizontal subsections you created in the previous step.

3 Place the Guideline of the Nose
This line may appear simple but its placement is crucial. Begin the line at the top of the circle at its highest point. Curve it gently down until it crosses the first horizontal line, creating a perpendicular intersection about one-fourth of the diameter of the circle. Continue the line, tilting it ever so slightly to make it reach the middle of the chin.

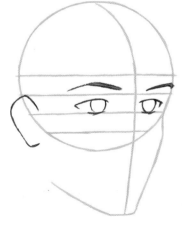

4 Place the Eyes and Ear
The ear touches the second horizontal line and extends to a place nearly as low on the page as the circle at its lowest point. The eyebrows are between the top two horizontal lines. Pay attention to the distance between the eyebrow line and the vertical guideline you added in the previous step. Note that the eye on the right side of the line is somewhat compressed and narrower from side to side than the other eye.

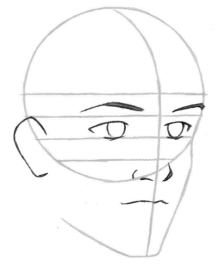 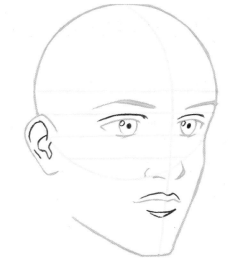 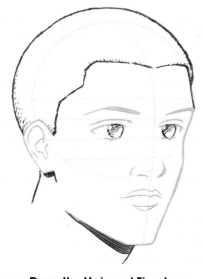

5 Draw the Nose and Mouth

The nose is composed of three lines, all centered around the point where the vertical line crosses the lower edge of the circle. This is one of the facial features that helps define the ethnicity of this particular character. A more typical manga nose is greatly de-emphasized and may amount to little more than a dot or two in this same area of the drawing.

6 Add Details

Add a line for the fold of the eyelid above each eye. The lines of the ear need not be as detailed as I've presented them here. Again, the depiction of the lips is related to this character's ethnicity, and the line of the upper lip in particular tends to be left out in depictions of the more typical manga character.

7 Draw the Hair and Fine-tune

The line of the hair is again placed a certain distance from the circle we started with. The line of the neck extends from a point midway across the ear and just to the left of the chin. Add shading to the eyes and shadows beneath the chin and ear to give depth to the drawing.

8 Finish It

 We're nearly done. Get your pen and ink the final lines. Let it dry, then erase the pencil lines for a professional finish.

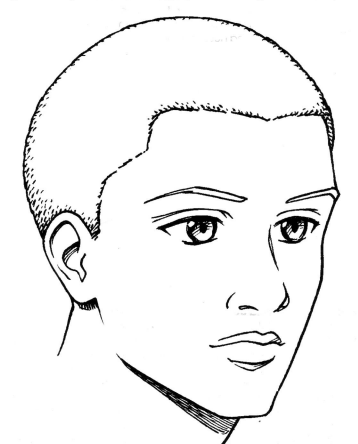

Female Hairstyles

When you're designing a character you'll want to pay special attention to the hairstyle. It's possibly the single most important way of projecting your character's personality to the reader. Here are a variety of approaches you can use for inspiration as you sit down to give your character just the right 'do.

Tightly-Curled Hair
Take your time as you indicate the individual coils. They spiral into individual lines as they reach the tips.

Long Straight Hair
The key here is to ink each long line with a single stroke of the pen.

Braided Hair
Braids can be an attractive way of setting a character apart.

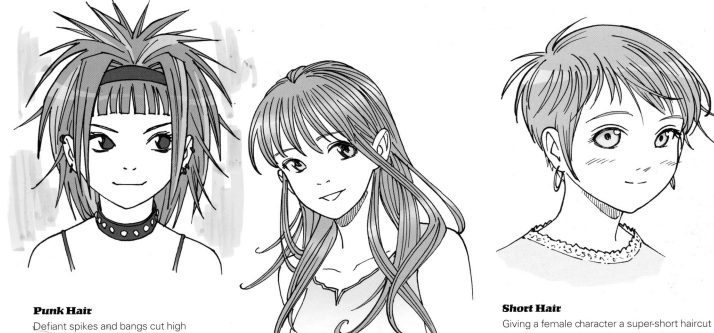

Punk Hair

Defiant spikes and bangs cut high on the forehead help to convey her individualist streak.

Short Hair

Giving a female character a super-short haircut is a bold choice. Go for feminine eyes if you're concerned readers may mistake her for a boy.

DRAW A BRAID

Follow the steps to learn how to draw a braid.

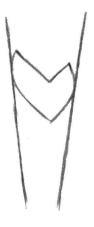

1 Draw two vertical lines, tilting diagonally at the top on both sides. In the middle, draw a lopsided heart shape, one side of it a touch longer than the other.

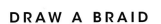

2 Repeat the shape above and below until you've filled the whole braid.

3 Add one diagonal line into the middle of each heart shape, dividing it into two parts roughly the same size. Add a little "ponytail" at the bottom.

4 Add lines for the individual strands of hair. Ink, let dry, erase the pencil and you're done!

Male Hairstyles

Male hairstyles are just as important as female hairstyles when it comes to differentiating one character from another. Think about your character's personality and choose a hairstyle that conveys it to the reader.

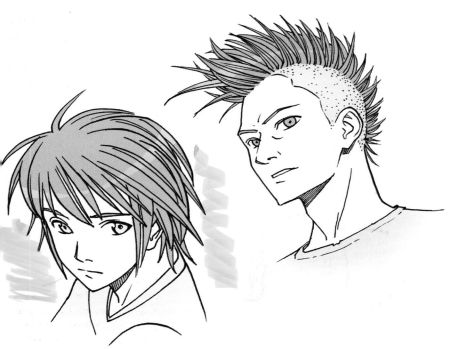

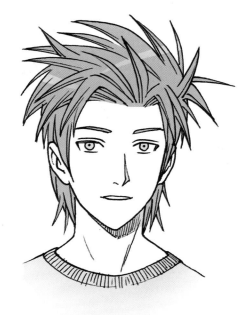

Spiky Hair

If you give one of your characters this type of hairstyle, try to organize the spikes so that you can draw them in roughly the same formation every time.

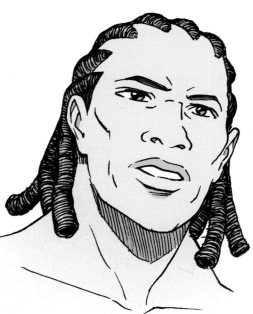

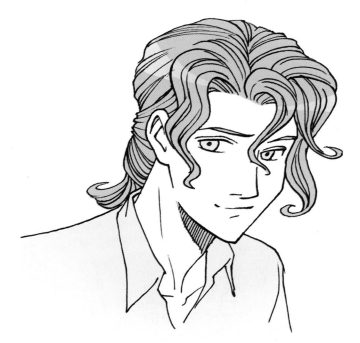

Dreadlocks

Arrange the dreadlocks so that they can all be traced to a particular origin on the scalp, then fill in the surface of each one with tightly-packed lines.

Wavy Hair

Drawing wavy hair requires a steady hand. Lay the individual lines in confidently, each with an individual stoke of the pen.

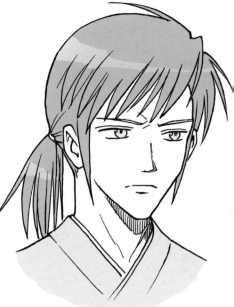

Short Hair

This hairstyle stays very close to the outline of the head and separates into tiny spikes all across its surface.

Ponytail

If you give a male character this hairstyle you may want to make his facial features extra masculine to ensure readers won't mistake him as female.

HIGHLIGHTS

When coloring both male and female hair, manga artists often leave a white "shimmer" across the top of the head to make the hair look shiny. Here are three different approaches you can use to achieve that effect.

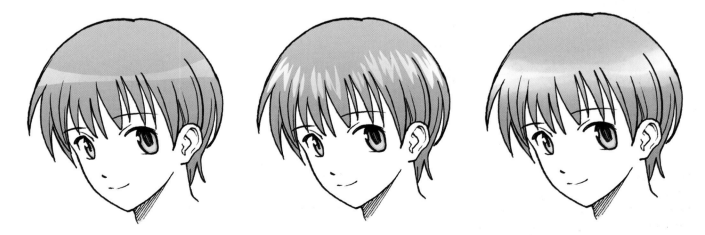

Female Bird's-Eye View

A manga artist sometimes chooses to give the reader an elevated point of view to create the effect of looking down on the character from higher ground. This bird's-eye view requires the illustrator to shift the facial features in unusual ways. Never fear—given the right guidelines, you can learn to draw this type of face with ease.

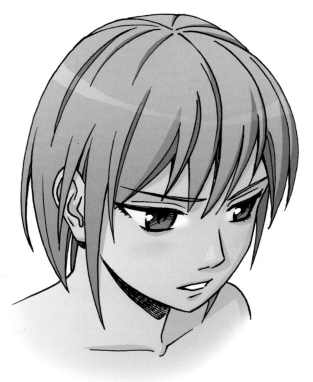

1 Draw Your Circle
Draw a rough circle. Add a gently-curving line at the bottom, so that it carves out a crescent moon shape that is at its widest about a fifth of the circle's diameter.

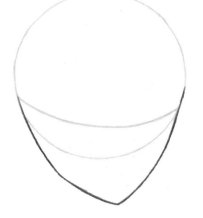

2 Mark the Jawline
Using a line that starts where the gently-curving line meets the circle, indicate the contour of the jaw, taking care to shift the chin just a touch to the right. If you look carefully you will see that an unusual shape is created between the edge of the circle and this jawline. Replicating that shape will help you get this line in the right place.

3 Add a Guideline for the Nose
Place another gently-curving line, this time vertically, to connect the top of the circle and the point of the chin. This line creates a new crescent shape within the circle that is nearly identical in size to the one created in step 1.

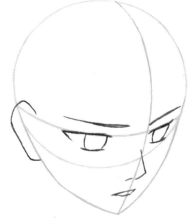

4 Place the Features
The ear connects the edge of the circle and the upper tip of the jawline. The eyes rest upon the curved horizontal line, with the eye on the left being almost twice the size of its counter-part on the right. The bridge of the nose rests upon the intersection of the circle and the curved vertical line. The mouth is equally distant from the chin and the bottom of the nose.

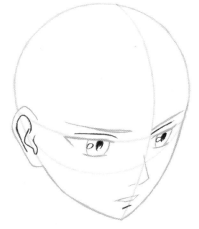
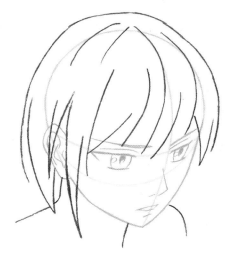
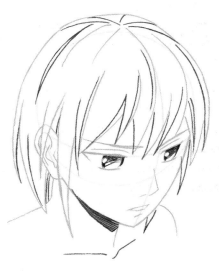

5 **Add Details**
The interior of the ear need not be as complex as I've rendered it here; simplify it if you like. The fold of the eyelid is not quite as wide as the eye itself. A simple line below the mouth defines the lower lip.

6 **Form the Hair, Neck and Shoulders**
Sketch in your hairstyle of choice, taking care to indicate the very top of the head—a point from which many hairstyles flow. The neck lines extend from the bottom of the ear and just left of the chin. Our bird's-eye view causes one of the shoulders to be partially obscured.

7 **Fine-tune**
Add further lines to define the hair as well as a shadow beneath the chin on the neck. I've put an indication of the collarbone as a finishing touch, as well as adding toning to the eyes.

8 **Finish It**
Ink the drawing, taking care not to ink any of the early guidelines you needed only for line placement. Let it dry, then erase the pencil lines. The finished drawing can be left as is, enhanced with gray tones, or given the full color treatment.

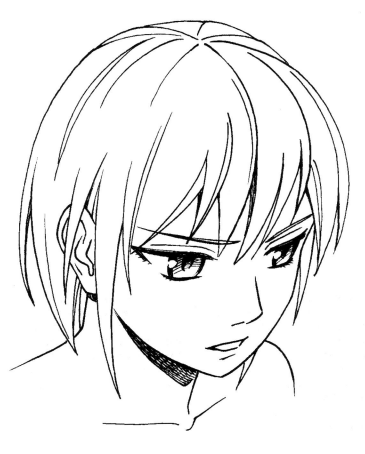

Visit impact-books.com/masteringmanga2 to download a free bonus demonstration.

Male Worm's-Eye View

The companion to the bird's-eye view is the worm's-eye view, through which the artist gives viewers the sensation of looking up at the character from below. To put an extra spin on things, I've decided to turn the character into a near profile, allowing us to catch only a glimpse of his other eye.

If you need to give your character a moment of dramatic heroism, the worm's-eye view may be just the thing you're looking for.

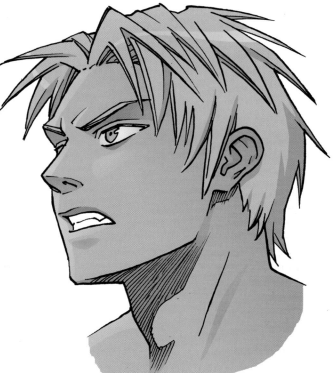

1 Draw Your Circle
Draw a rough circle. Add a gently curved line across the top, creating a crescent moon shape that is about one-third of the circle in diameter. Note that the line is slightly tilted, so its left tip is considerably lower than its right tip. This will allow us to place the eyes later on.

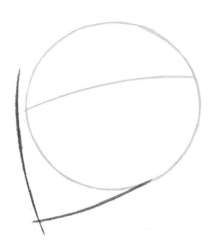

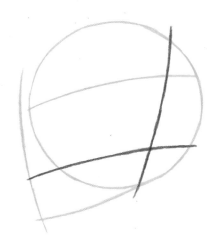

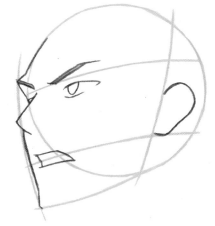

2 Mark the Jawline
Start with a slightly curved vertical line that nears but doesn't quite touch the circle. This line is also tilted just a touch to the left. Now add a curved diagonal line that extends from the circle to touch the vertical line at a point well below the lowest point of the circle.

3 Add Guidelines for the Ear and Mouth
Place a slightly diagonal line across the right side of the circle, creating a crescent moon shape that is around one-fourth of the diameter of the circle. Add a gently curved line that mirrors the one drawn in step 1. This will allow us to place the mouth in the next step, so it needs to be considerably closer to the jawline than to the eye line above.

4 Place the Features
Draw the eyes and the eyebrows. Pay attention to the small distance between the eyes and the guideline above them. The nose begins at the eye line and extends to an area just outside the circle. The mouth is centered on the line we drew in step 3, overlapping the edge of the circle just a touch. The ear rests upon the mouth line and the vertical line.

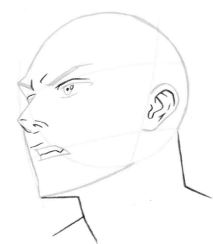
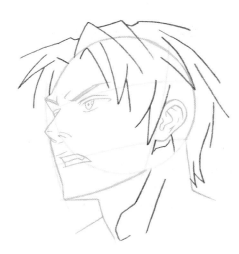
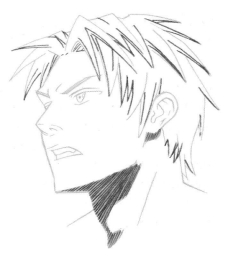

5 Add Details

The interior of the ear need not be as complex as I've rendered it here; simplify it if you like. The details of the eyes are now accompanied by lines above the eyebrows that suggest a look of added concentration. The worm's-eye view allows us to see the underside of the nose—pay close attention to the delicate arrangement of lines here. This character's neck is wide and muscular, so it extends from the mouth line on the left edge of the circle and joins the jaw in an area that lines up with the right edge of the mouth.

6 Form the Hair and Neck

Sketch in your hairstyle of choice. The worm's-eye view obscures the top of the head, so you may need to alter the various strands of your character's hairstyle accordingly. Our vantage point gives added emphasis to the neck, so we need to rope off a larger area of shadow than usual.

7 Fine-tune

Add further lines to define the hair, as well as a shadow beneath the chin on the neck. I've put a bit of shading beneath the ear as well.

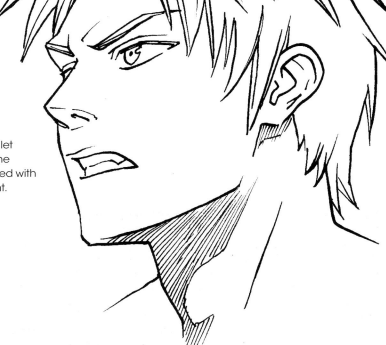

8 Finish It

You know the drill: Ink the drawing, let it dry, then erase the pencil lines. The finished drawing can be left as is, enhanced with gray tones, or given the full color treatment.

Fantasy Cat Girl Character

Fantasy elements have been a part of manga from the very earliest days of the art form, so you may want one of your characters to be something truly out of the ordinary. There are endless varieties to choose from when it comes to fantasy characters, but I've decided to opt for one of the perennial favorites—the cat girl.

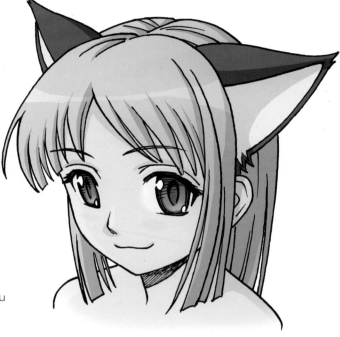

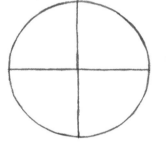

1 Draw Your Circle
Draw a rough circle, neatly divided by a vertical line and a horizontal line. The vertical line is there to help you place one of the eyes. The horizontal line will help you find and place the eyebrows.

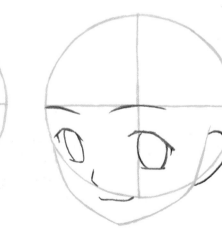

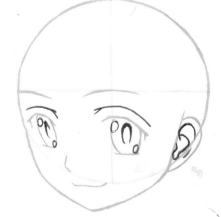

2 Mark the Jawline
Start with a slightly diagonal line that leaves the circle just below its left edge. It soon curves into a more decisively diagonal line until it reaches the point of the chin, in an area just to the lower left of the lowest point of the circle. Now it heads back toward the circle, curving up to land at a point high in the lower right quadrant of the circle.

3 Place the Features
Draw the eyebrows so that they rest upon the horizontal line. The eye that is closest to us touches the vertical line, while the other eye nears but doesn't quite touch the edge of the circle. The nose and mouth touch the edge of the circle near the bottom of its lower left quadrant. Note the shape of the mouth is curved to resemble that of a cat. Add a human ear if you like—the manga illustrations I've seen generally do.

4 Add Details
Draw the folds of the upper eyelids so that they are slightly closer to the eyes than the eyebrows. I've chosen to add two highlights to each iris to make the eyes extra shiny. The details of the interior of the ear can be minimized if you like.

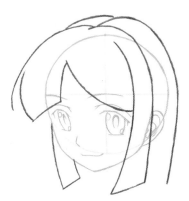

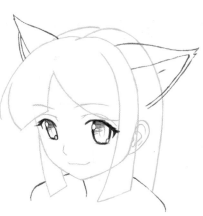

5 Form the Hair
Sketch in the basic guidelines of whichever hairstyle you prefer. I've opted for long squared-off strands of hair across the cheeks. This drawing has a slight bird's-eye aspect to it, so we are able to see the top of her head to some degree.

6 Draw the Cat Ears, Eyes, and Shoulders
Add the basic shape of the cat ears, taking special care to make the one closest to us larger than the one farther away. The interior section of the far ear is largely obscured. I've indicated little tufts of hair near the tips of the cat ears. Add details to the eyes as you see fit. My personal preference is to add shading near the top of each iris.

7 Fine-tune
Add further lines to define the hair, as well as a shadow beneath the chin on the neck. I've added some tufts of fur near the base of the cat ears as a final touch.

8 Finish It
Ink the drawing, taking care not to ink any of the early guidelines you needed only for line placement. Let it dry, then erase the pencil lines. The finished drawing can be left as is, enhanced with gray tones, or given the full color treatment.

Facial Expressions

Learning manga facial proportions is essential, but once you've got them down you get to move on to the fun part—putting emotions on your characters' faces. There are countless varieties of subtle emotions you can go for. Here are five of the most important ones.

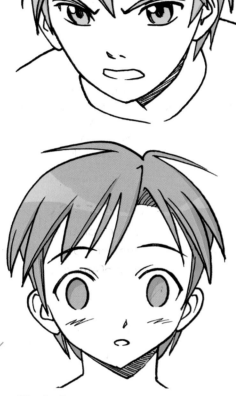

Angry/Determined

The eyes have relaxed a touch, with the irises partially overlapped by the upper and lower eyelids. The angle of the eyebrows is crucial, as is their proximity to the eyes. Those little hooks at the bottom tip of each eyebrow add to the intensity, suggesting a furrowed brow. Finally the mouth, rendered to convey clenched teeth, shows his refusal to back down.

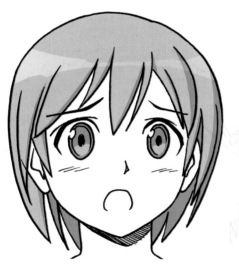

Stressed/Concerned

The key to this expression is the angle and curve of the eyebrows combined with the wide-open eyes. The fact that we can see the entirety of her iris shows that she's on edge and can't relax.

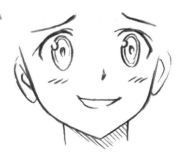

Variation: Embarrassed

To change the stressed look to one of embarrassment, simply change the mouth to a smile.

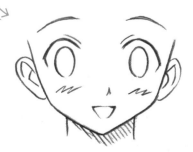

Shocked

The eyes are open enough to reveal the entire iris. The pupils have vanished, creating a blank look that manga artists love to deploy when a character is stunned by new revelations. Note the distance between the eyebrows and the eyes—a signal of surprise on the human face.

Variation: Pleasantly Surprised

All it takes is an added smile to transform the shocked look into one of pleasant surprise.

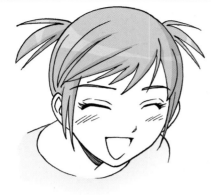

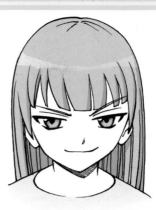

Elation

The curving bold black lines of the eyes are the embodiment of manga happiness. This is a somewhat tame version. Experiment with a dramatic curve if you want to go for something more cartoonish. Note the tiny gap in the contour of the mouth. Manga artists often leave such breaks in a line to let the drawing breath a little.

Deviousness

The trick to this expression is the combination of angry-looking eyebrows with a smile. Note how much the tops of the irises are obscured by the eyelids. This adds to her look of smugness. Making the smile a little lopsided can enhance the feeling that she's up to no good.

ADD EXPRESSION TO A FACE

Adding emotion to a character's face can be achieved with surprisingly few lines. Follow the steps to learn how to change a blank expression into one of embarrassment.

1 Draw a young man's face in pencil. Leave off the eyebrows, the irises and the mouth.

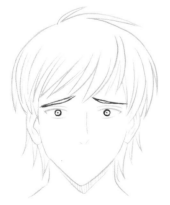

2 Add the eyebrows, tilting them so they curve upward in the middle of his forehead. Add the irises. Make them small enough that we can see a gap between the bottom of the irises and the lower eyelid.

3 Add diagonal blush lines spreading across his cheeks and the bridge of his nose. Draw his smile. Make it slightly asymmetrical to convey his unease.

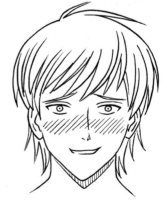

4 Ink the lines. Let the ink dry, then erase all the pencil lines. Voila! You have made this young man appear thoroughly embarrassed.

Eyes and Ears

There is no end to the variety of manga-style eyes. You can experiment with as many approaches as you care to, from tiny eyes readers can barely see to eyes so big they dominate the entire face.

Ears are usually relegated to a supporting role by manga artists, and they are rarely drawn in a manner accurate to actual human anatomy.

Compare the differences between a human eye, a slightly stylized manga eye and a highly stylized manga eye, and the difference between a human ear and a typical manga ear in the images below.

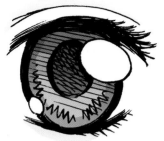

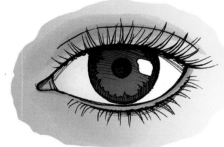

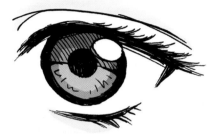

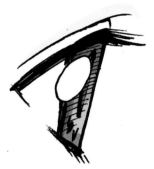

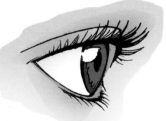

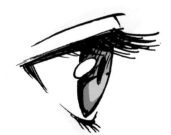

Highly Stylized

All the aspects of the previous eye have been taken to their logical extreme. The highlight has grown in size as has the pupil, which is now fully half the width of the iris. Note that in profile the contour of the eye, rounded in the other two versions, has become flat.

Real Anatomy

Here you see what a real eye looks like from the front and in profile. The tear duct is clearly visible. The eyelashes extend all along the upper and lower eyelids. The pupil is about a quarter of the width of the iris.

Slightly Stylized

This eye displays many of the most common manga eye traits: The tear duct has completely vanished and the lower eyelid is de-emphasized in comparison to the upper eyelid. The eyelashes are visible in some areas and omitted in others. The pupil is about a third the width of the iris.

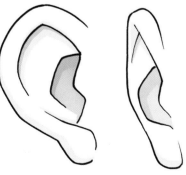

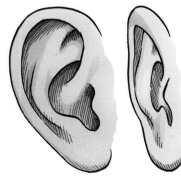

Real Anatomy

Here you see the anatomy of the human ear, as seen from the front and from the side. It is a fairly complicated structure, challenging to draw accurately from memory.

Manga Anatomy

This is what such an ear becomes in the hands of a manga artist. You can see similarities with real human anatomy, but the artist is simplifying things in order to produce something more stylized.

Noses and Mouths

Just as with eyes and ears, manga noses and mouths can be drastically different from what is found in true human anatomy. It is instructive to compare real-life versions with the manga versions to see what changes.

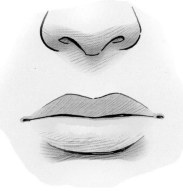

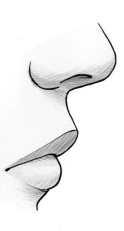

Real Anatomy

The nose's width is more than half that of the mouth, and its structure is fully visible. Note how in profile, the upper lip rests upon the lower lip, creating a real life contour that is quite subtle in its curves.

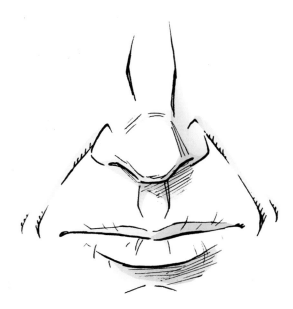

Fully Rendered Noses

Not all manga characters have minimized noses. Older characters and certain types of younger characters may have more fully rendered noses.

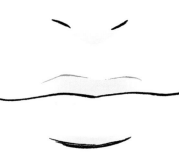

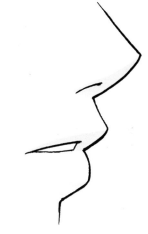

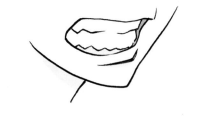

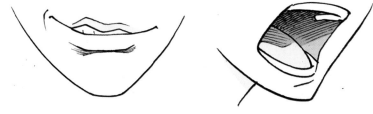

More Mouth Expressions

Here are some images you may refer to when wishing to draw your character's mouth in certain dramatic circumstances: teeth gritted, sneering or shouting.

Manga Anatomy

A manga artist is very reluctant to fully render a character's nose, especially if the character is meant to be young and attractive. Often all one sees is a couple of dots depicting the nostrils, or some vague suggestion of the nose's tip. Frequently, the mouth is not as rendered as seen here. A single line may be all that's needed.

In profile, manga artists often take the liberty of shifting the mouth off to one side, offering a true profile view of the face in combination with a near-profile view of the mouth. Manga noses often come to a point rather than being rounded as they are in real life.

Glasses

Giving glasses to one of your characters can be a nice way of distinguishing them from others in the story. Use these reference illustrations for ideas on how to make a pair of glasses fit onto a character you've designed.

Half-There Glasses

Sometimes manga artists will allow parts of the eyeglass frames to vanish. It's a nice way of having your character wear glasses without obscuring too much of her eyes.

Dark Glasses

Giving your characters shades will definitely set them apart as cool. In manga, where expressive eyes are king, completely hiding eyes is a bold choice.

Side View

You'll want to practice drawing glasses from the side for the occasional profile view. Artists will generally find a way of preventing the frames from blocking the irises.

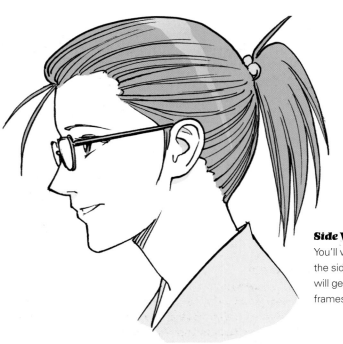

Hats

Giving characters hats can be an even more dramatic way of setting them apart. If you decide to add to your character's design this way, these illustrations can help get you started.

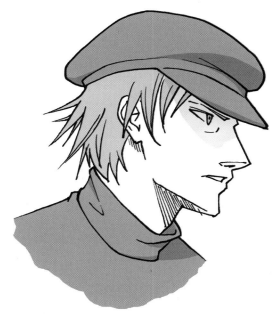

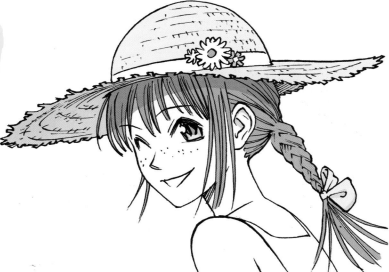

Steampunk Hat

This style of top hat is a must for any Steampunk story you may be working on. Note the shape of the brim and how it crosses the forehead an inch or so above the eyebrows. This approach is common for male characters, who are often depicted with their hats tight-fitting and low on the head.

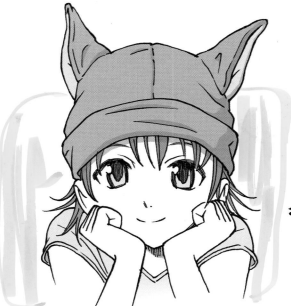

Pointy-Ear Hat

This style might be nice for one of your more "crafty" characters. The wrinkles suggest it was sewn from fabric. Perhaps she made it herself?

Summer Hat

The key to drawing this hat is getting the gentle S-shaped brim positioned just right so that you see its upper surface on one side and its lower surface on the other side. Note how she is wearing it higher on her forehead than her male counterparts above.

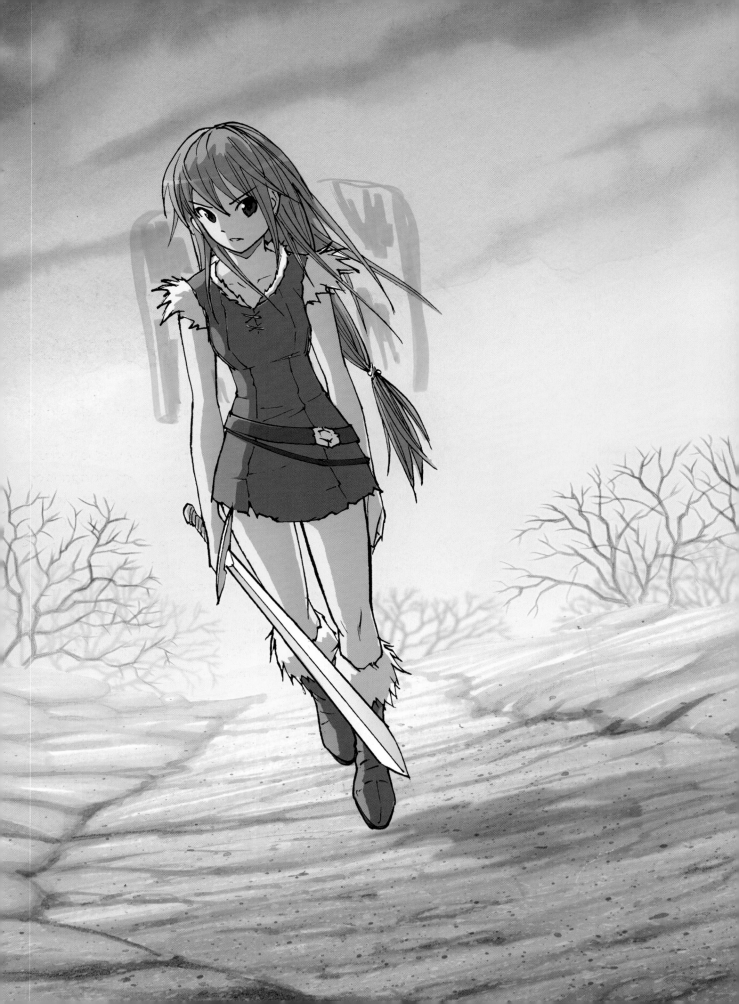

 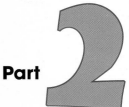

Proportions and Poses

The next logical step in one's manga studies is rendering the human body. After all, what good is it to be able to draw a perfect manga face if the body you've drawn beneath it is completely out of proportion?

The good news is that those same principles you applied to learning how the face is rendered—patience and careful attention to line placement—are the very things you need for honing your skills in drawing the human body.

Visit impact-books.com/masteringmanga2 to download a free bonus demonstration.

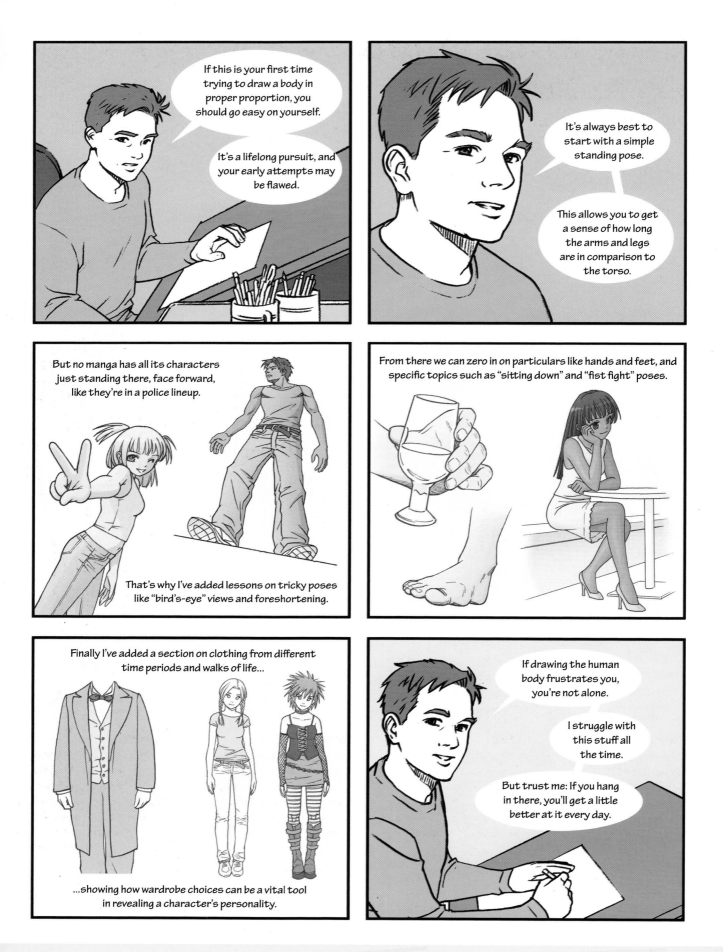

If this is your first time trying to draw a body in proper proportion, you should go easy on yourself.

It's a lifelong pursuit, and your early attempts may be flawed.

It's always best to start with a simple standing pose.

This allows you to get a sense of how long the arms and legs are in comparison to the torso.

But no manga has all its characters just standing there, face forward, like they're in a police lineup.

That's why I've added lessons on tricky poses like "bird's-eye" views and foreshortening.

From there we can zero in on particulars like hands and feet, and specific topics such as "sitting down" and "fist fight" poses.

Finally I've added a section on clothing from different time periods and walks of life...

...showing how wardrobe choices can be a vital tool in revealing a character's personality.

If drawing the human body frustrates you, you're not alone.

I struggle with this stuff all the time.

But trust me: If you hang in there, you'll get a little better at it every day.

Body Proportions From Toddler to Adult

Body proportions change drastically as one ages, especially in the early years of childhood. Use this chart as a guide when designing characters of different ages or when showing one of your grown-up characters as a child in flashbacks.

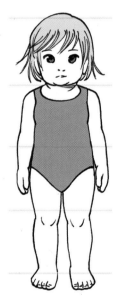

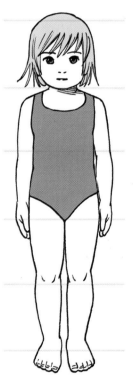

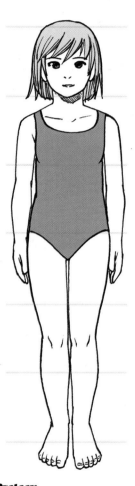

Toddler

At only four heads tall, we can see that this child has only just started walking. The neck is barely visible, and the arms and legs are similar in length.

Child

Now at five heads tall, we can see this child as more in the range of preschool or kindergarten. The legs are still rather short compared to the proportions of late childhood.

Preteen

At six heads tall now, we see her on the verge of adolescence. The legs are noticeably longer than the arms, and the neck is much longer than it was at earlier stages of development.

Adult

At seven heads tall, she has reached adulthood. The difference in length between her arms and legs has become even more pronounced. The width of her waist compared to her hips was negligible in childhood but is now very clear.

The Teenage Girl

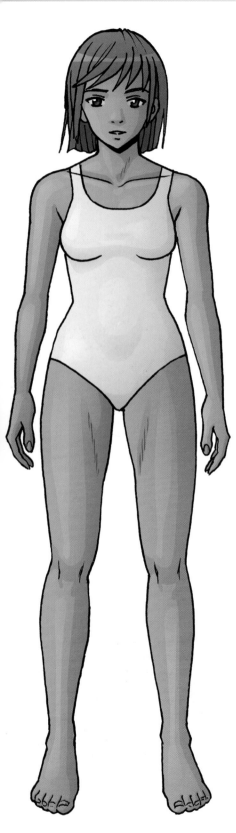

Getting a sense of proper body proportions is essential to drawing all but the most cartoonish pictures. Even if you prefer highly stylized artwork, it's always best to study accurate human anatomy to get a sense of which rules you're choosing to break.

In the first *Mastering Manga* book I presented a fairly exaggerated version of body proportions to keep things simple. This time I want to "level up" with something closer to real life.

1 Build the Frame
Start with seven horizontal lines, evenly spaced. Draw a female manga face using what you've already learned.

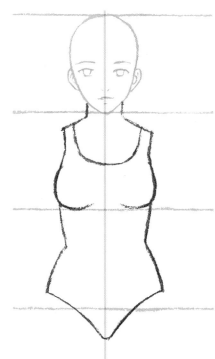
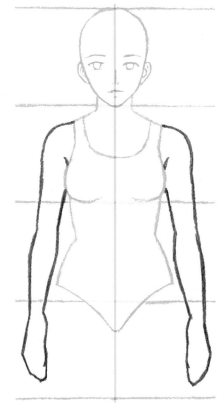

2 Create the Torso
Draw the neck, shoulders, and torso. Use the horizontal lines as guides to help you see where the lines go. The shoulders begin just past the second horizontal line. The breasts rest upon the third line. The waist line is about halfway between lines 3 and 4. Go slowly and don't attempt to just replicate the lines—try to get the shapes.

3 Add the Arms and Hands
Add the arms and rough indications of the hands. The elbows are closer to line 3 than line 4. The wrists are just below line 4. The width of each part of the arm is every bit as important as the length. Look at the width of the forearms at their widest. Then look at the way you've drawn them. Is your version too wide? Too narrow?

4 Sketch the Legs and Feet
Add the legs and rough indications of the feet. This will be one of the most challenging parts of the drawing. Go slowly, with super light lines. The knees are closer to line 6 than to line 5. The ankles fall just below line 7. Observe the width of each part—the thighs are a good deal wider than the calves are. The knees are nearly twice as wide at the ankles.

Visit impact-books.com/masteringmanga2 to download a free bonus demonstration.

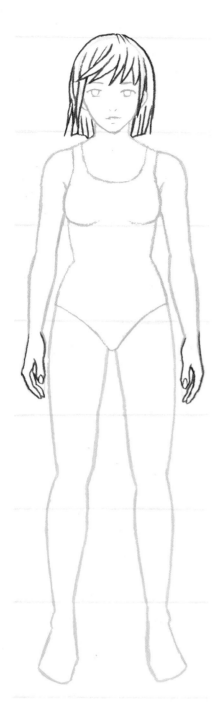

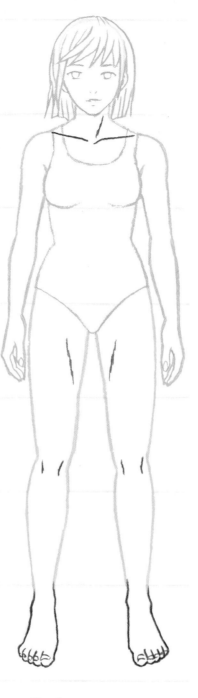

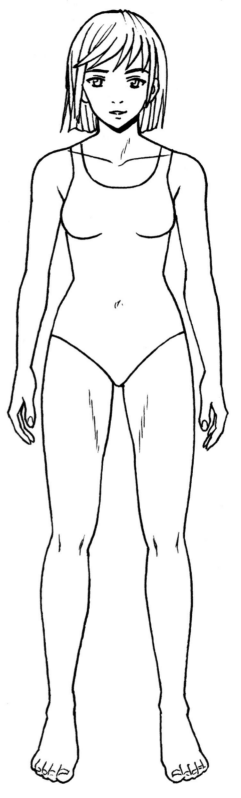

5 **Add Details**
Draw the hair and the hands. No need to replicate this particular hairstyle; be creative and choose any style you like. Take your time with the hands—they are always challenging.

6 **Fine-tune**
Draw a few lines to delineate the collarbone and a couple short lines to indicate each of the knees. Draw the feet, taking care to include the contours of the ankles.

7 **Finish It**
Ink all the lines. Let the ink dry, then carefully erase. You've done it—a teen girl, head to toe, in proportions that are quite close to real human anatomy.

Female Body in Profile and From Behind

In learning body proportions it is natural enough to study someone from the front. But once you start trying to tell a story, you will find that you sometimes need to draw your character in profile and from behind.

Use this page to get a more fully rounded idea of your character's body proportions when viewed in profile or from behind.

From Behind

The contour lines of the body from behind are much the same as they are from the front, but the artist is faced with challenges in drawing this pose properly. When the head faces away from the viewer, all that remains visible is the back of the ears. The feet can be tricky—you must render the heel but also the rest of the foot in a foreshortened state.

In Profile

When studying the human body from the side, you'll see that a person doesn't stand completely straight like a stick figure, but instead leans a bit forward to achieve real balance. The arms are very near the back, hanging down from the shoulders at a considerable distance from the front of the body.

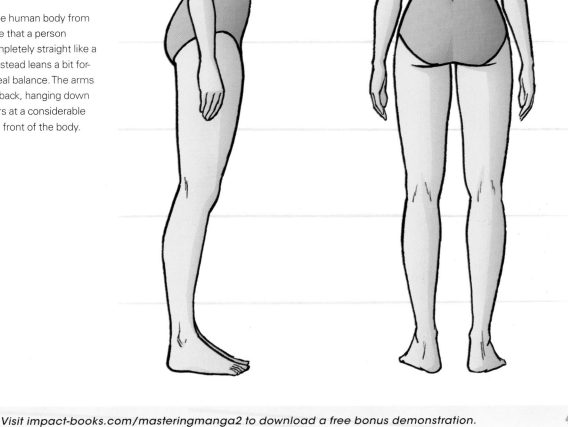

The Teenage Boy

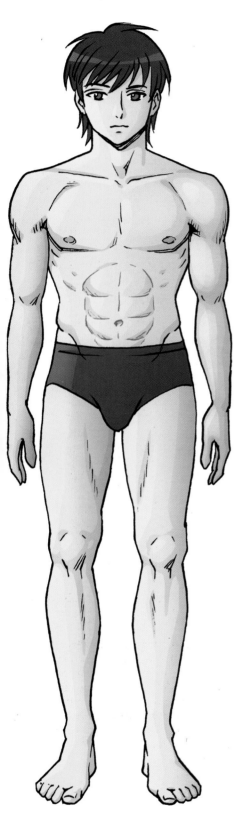

There are many different body types out there, and not everyone looks like a body builder. But when studying male anatomy, it is worth learning the locations of various muscles so you can draw them when needed.

Manga artists play around with body proportions to achieve various effects. Reducing the width of this character's shoulders, for example, will make him appear a little less athletic.

1 Build Your Frame

Draw seven horizontal lines, equally spaced. You'll want them to be at least an inch or more apart to allow space for details later on. Draw your character's head (without hair) between lines 1 and 2.

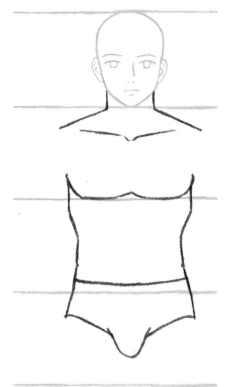
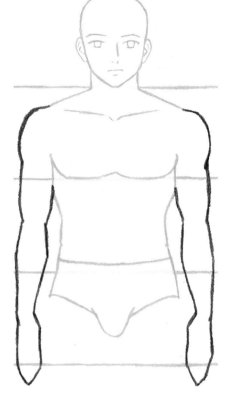

2 Create the Torso
Draw the neck, shoulders and torso. Use the horizontal lines as guides to help you see where the lines go. The shoulders begin just past the second horizontal line. The shoulder area is roughly two heads wide at this stage. The pectoral muscles rest upon line 3. The waist-line is just above line 4. Go slowly and attempt to replicate not just the lines, but the shapes that they form.

3 Add the Arms and Hands
Add the arms and rough indications of the hands. The elbows are between lines 3 and 4. The wrists are between lines 4 and 5. The width of each part of the arm is every bit as important as the length. Note how wide the arms are at the shoulder and how narrow they are at the wrist.

4 Sketch the Legs and Feet
Add the legs and rough indications of the feet. The knees rest upon line 6. Men's legs are often drawn more angular than women's legs. Note the small protrusions at the ankles, as well as the width of the thigh compared to the calf.

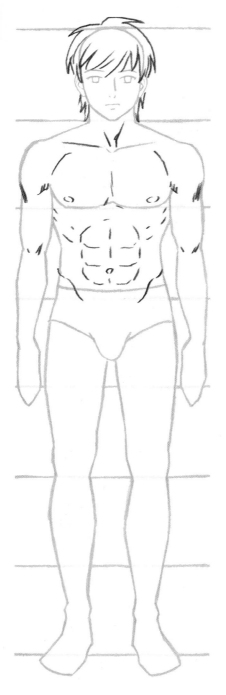

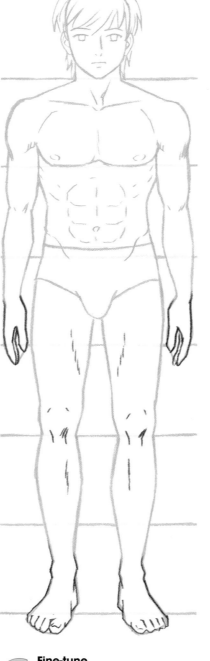

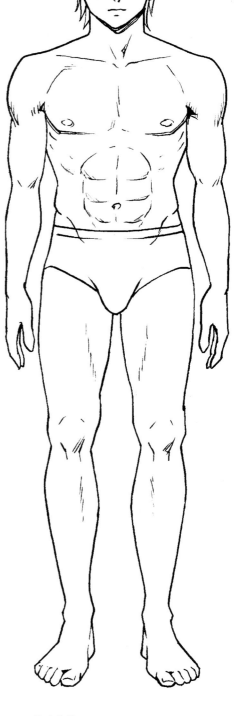

5 Add Details

Draw the hairstyle you prefer. Now add lines for the muscles, taking care to place each line in its proper location. The "six pack" muscles vary from one man to another, but you will indeed sometimes see the divide into six subsections. Small lines on the upper arms will help define the muscles there.

6 Fine-tune

Draw the hands and feet and add detail to the legs. Take your time with the fingers—the length and placement of each line is crucial. The knees are defined by lines below and, if you like, a couple of small lines above. An athletic character may have subtle shading on the inner thigh to indicate muscles there.

7 Finish It

Ink all the lines. Let the ink dry and then carefully erase. You can add gray toning, color, or leave it as is.

Male Body in Profile and From Behind

The male body in profile creates a very different contour from that of a female character. In addition to the shapes being different, the lines are often rendered in a more angular fashion to emphasize the masculinity of the character.

From Behind

The shoulders are often given extra breadth by artists wishing to make the character appear athletic. When rendering the elbows it is best to keep the lines small and subtle. The muscles of the back are clustered around a central vertical line between the shoulder blades. This point of view may allow us to see some shading below the calves.

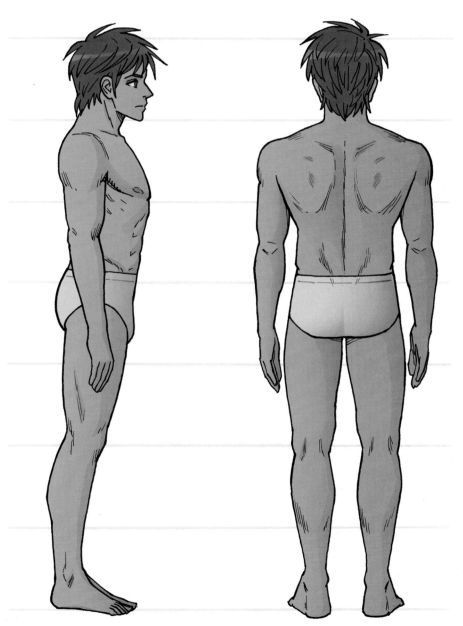

In Profile

A male character in profile also leans a bit forward to achieve balance. Again, the arms are near the back at the shoulders, with the hands resting at the mid thighs. The lines of the ankle become visible from this point of view, as well as muscles at the back of the knee.

Bird's-Eye Body Proportions

One of the joys of creating comics is having the ability to give the reader any point of view you like. Like a film director, you may decide the drama of some moments demands a crane shot. In such situations you will need to draw your characters from above—the bird's-eye view. It's a drawing challenge to be sure, but one that any artist can master given enough practice.

1 Build Your Frame
Draw five horizontal lines, equally spaced. You'll want them to be at least two inches or more apart to allow space for details later on. Draw your character's head (without hair) between lines 1 and 2.

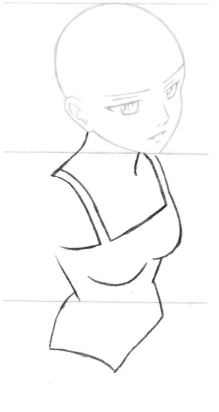

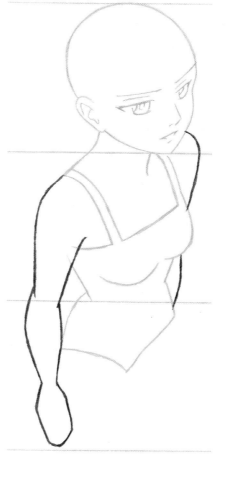

Create the Torso

2 Draw the neck, shoulders, and torso. Use the horizontal lines as guides to help you see where the lines go. Our character is standing at an angle, so one shoulder will be higher than the other. The waist rests upon line 3. The forced perspective of the bird's-eye view causes the head to appear wider than the hips.

Add the Arms and Hands

3 Add the arms and rough indications of the hands. The elbow on the left rests upon line 3. The shoulder on the right is above line 2, while the shoulder on the left is well below it.

Sketch the Legs and Feet

4 Add the legs and rough indications of the feet. Her angled stance causes the foot on the left to cross line 5, while the foot on the right is closer to line 4. The bird's-eye view causes her feet to appear very small indeed.

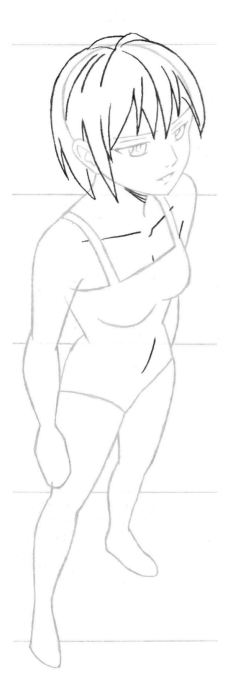

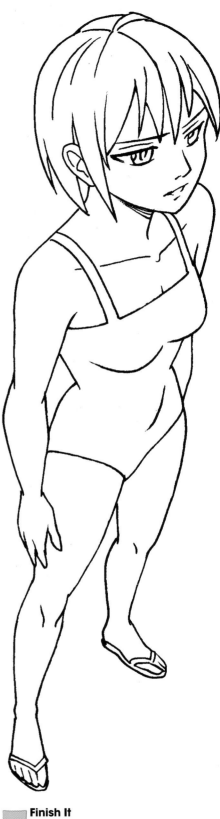

Add Details

Draw the hairstyle of your choice. Add a touch of shading beneath the chin on the neck. Draw a line across her upper torso to indicate the collar bone. Add a single line on the abdomen to suggest the contour of her belly.

Fine-tune

Draw the hands and the feet. From this point of view, some of her fingers are obscured. A line or two at the knee is all you need to define that area. The angles of her feet will help to convey her confident stance.

Finish It

Ink all the lines, let the ink dry, then carefully erase. With practice, bird's-eye views like this will become a drawing trick you can pull out any time you need.

Female Back and Neck

The juncture of the neck, shoulder, and back is not a topic that gets a lot of attention in most drawing books, but it is as important as it is difficult to master. Focusing on it now will help you get a handle on the way these parts of the body come together.

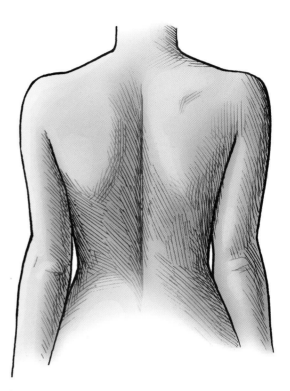

Turning the Head Back

One tricky pose that often becomes necessary in storytelling is that of a character who is facing away from us and turning her head back to see something or deliver a final line over her shoulder. This pose creates a tiny gap between her shoulder and chin, as well as a wrinkle on her neck.

The Back

The contours of a woman's back are different from those of a man, and artists will often play up those differences, making the female characters extra feminine. This means subtle curving lines, not sharp angles. As with men, though, a single vertical line forms between the shoulder blades, extending from the upper back to the waist.

The Neck

The female neck is generally portrayed as narrower than a man's, and no indication of an Adam's apple is needed. Note the subtle protrusion of the collarbone and the distance between the neck line and the tip of the chin.

Worm's-Eye Body Proportions

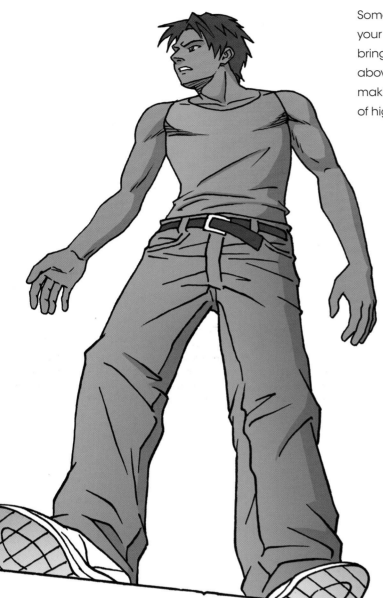

Sometimes your story will call for a low-angled shot. In your role as "manga-movie director," you will need to bring the camera down to make your character tower above the readers. It is an especially useful angle for making a character appear extra heroic at a moment of high drama.

1 Build Your Frame
Draw nine horizontal lines, equally spaced. You'll want them to be at least an inch or more apart to allow space for details later on. Draw your character's head (without hair) between lines 1 and 2.

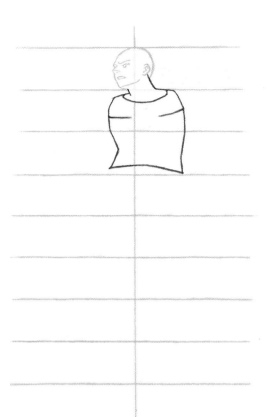

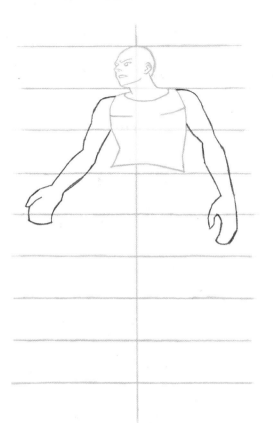

Create the Torso

2 Draw the neck, shoulders, and torso. Use the horizontal lines as guides to help you see where the lines go. The shoulders begin just past the second horizontal line. The shoulder area is roughly two heads wide at this stage. The pectoral muscles are between lines 2 and 3. The waistline is just above line 4. The forced perspective of the worm's-eye view causes the waist to appear equal in width to the shoulders.

Add the Arms and Hands

3 Add the arms and rough indications of the hands. The elbows are between lines 3 and 4. The wrists are between lines 4 and 5. The width of each part of the arm is every bit as important as the length. The perspective of the worm's-eye view causes his hands to appear larger than his head.

Sketch the Legs and Feet

4 Add the legs and rough indications of the feet. The forced perspective becomes very apparent at this stage, with the feet dwarfing the head in size. He is standing on a ledge, allowing the viewer to see the soles of his shoes.

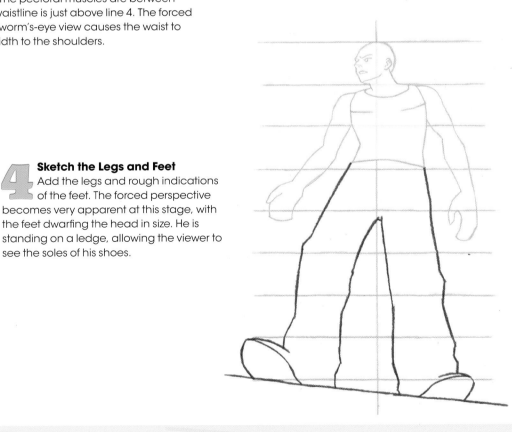

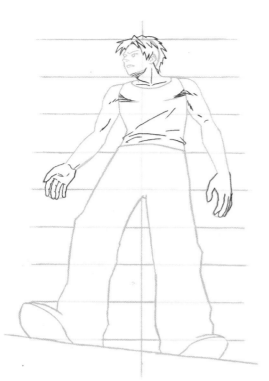

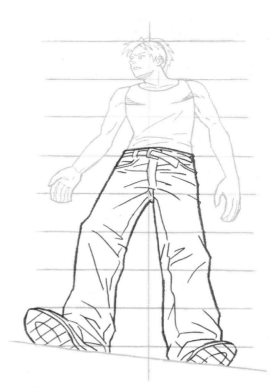

5 **Add Details**
Draw the hairstyle you prefer, then add shading to the pectoral muscles. A few carefully placed lines will define the neck muscles and collarbone. The hands are seen at different angles in this pose, with the palm visible on the left and the back of the hand visible on the right. Add clothing wrinkles at the waist for further realism.

6 **Fine-tune**
Add details to the blue jeans and shoes. The seams along the insides of the legs help us to understand the structure of the clothing. I opted for a relatively simple pattern on the soles of the shoes, but you should feel free to try something more complex if you like.

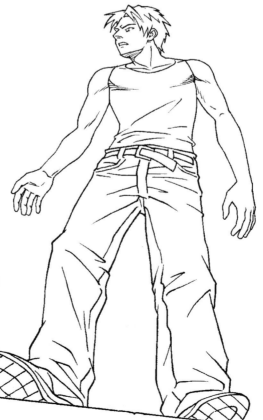

7 **Finish It**
Ink all the lines. Let the ink dry and then carefully erase. You can add gray toning, color, or leave it as is.

Male Back and Neck

Artists often emphasize the muscles when drawing male characters, and this certainly applies when drawing the neck, shoulders, and back. The muscles of the back are more subtle than they are in other parts of the body, so this page can serve as useful reference when it comes time to draw your male characters from behind.

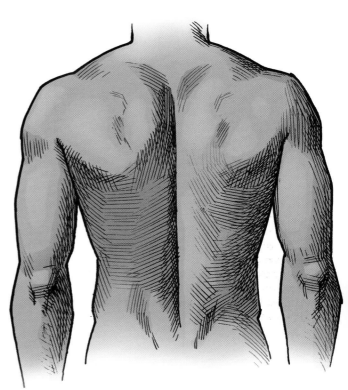

Turning the Head Back
When a male character who is facing away from us turns his head back, the crease that forms along his neck becomes plainly visible. Note the shapes of his back muscles when seen from this point of view.

The Back
The muscles of a male character's back will often be rendered with greater angularity than would be the case with a female character. In both cases though, a single vertical line forms between the shoulder blades to define the back's structure. There are small indications of muscles in the lower back area. Also, note the highly defined elbows—something artists generally avoid when rendering female characters.

The Neck
The male neck is usually portrayed as thicker than a woman's, and there is almost always some indication of an Adam's apple. Note the protrusion of the collarbone and the highly defined musculature of the neck.

The Hand

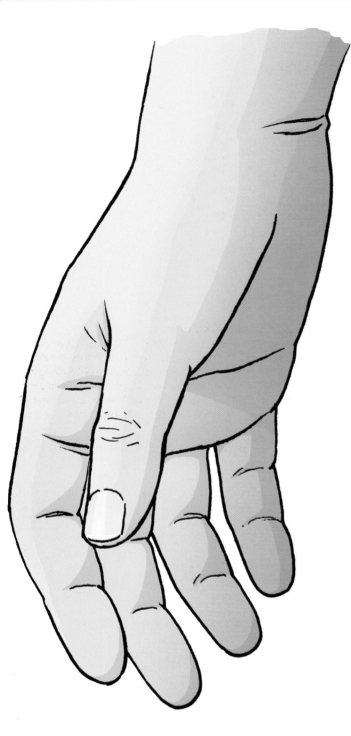

For the vast majority of us, drawing the hand is a huge challenge. The complexity of its structure results in an infinite variety of possible poses and configurations. It is worth drawing your own hand, palm facing forward, to help you memorize the length of each finger in comparison with the thumb and the rest of the hand. For this step-by-step lesson, though, I have chosen one of the most common poses—that of the hand at rest when the arm is relaxed.

1 Build Your Frame
Draw two square boxes, one on top the other. Make the squares at least two inches on each side to allow for details later on.

2 Rough In the Palm

Draw the rough shape of the palm. It is an unusual shape, so take your time and use the grid structure to help you see where the lines go. The curved line at the bottom will be where you add the fingers later on.

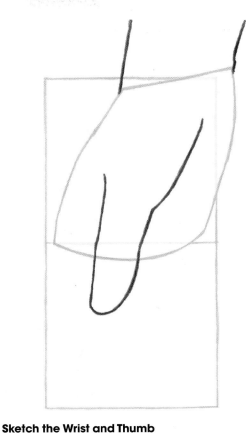

3 Sketch the Wrist and Thumb

Add lines for the wrist and for the thumb. If you have made the palm shape accurately, the wrist line on the left will be near the middle of the top square, but slightly closer to the left edge. The thumb is divided into two subsections—an indication of the palm at the top, and the thumb itself below. Take care to observe both the length and width of the thumb. It is about one-quarter as wide as the squares in step 1.

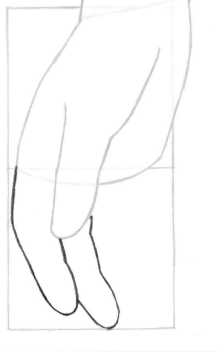

4 Draw the First Two Fingers

Add the first two fingers. The second one touches the bottom line of the grid. The first one (the index finger) is slightly shorter. Look at your own hand as reference for their difference in length. Each finger has joints that divide it into three subsections of roughly equal length.

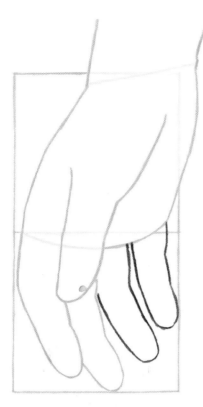

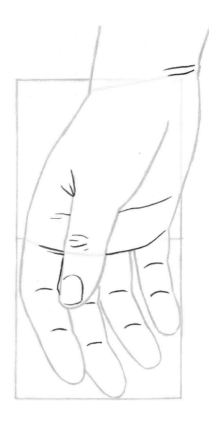

5 **Add the Other Fingers**
Draw the other two fingers. The one on the left is about the same length as the index finger. The pinkie is noticeably shorter. Again, examining your own hand will allow you to study and eventually memorize the lengths of the various fingers.

6 **Add Details**
Add wrinkles to the wrist, the palm and the joint of the thumb. You can add a few wrinkles at the thumb knuckle if you like. The thumbnail is plainly visible from this point of view. A simple line at the joints of each finger completes the drawing.

7 **Finish It**
Ink the drawing, taking care not to ink any of the early guidelines you needed only for line placement. Let it dry, then erase the pencil lines.

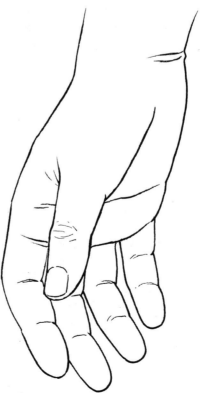

More Hands

Hands can sometimes say almost as much about your character as the face does. However, not all hands look alike. Use this page for ideas on how to make some of your characters' hands more distinctive.

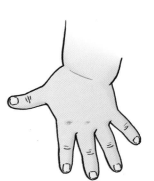

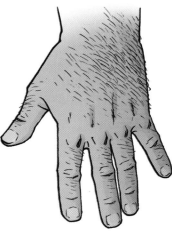

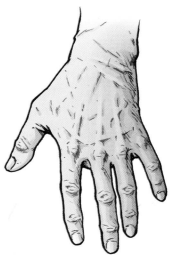

Babies
A baby's hands are small and more rounded than a grown-up's hands. The fingers are a bit stubby, and the fingernails are quite tiny.

Tough Guys
In addition to the obvious hairiness, the hand of this hardened tough guy has very pronounced knuckles and indications of musculature.

Elderly
An older character's hands reveal their age by way of wrinkles and bone structure. The knuckles can become very wrinkly, and veins may crisscross the back of the hand.

DRAW A HAND HOLDING A SWORD

One common element of an action-adventure story is a character gripping a sword. Follow this lesson to draw your character's hand so that the fingers close around the hilt in a natural and convincing way.

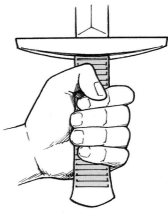

1 Draw a few rough lines for the outlines of the fist. The hilt of the sword will be closer to the right edge of this shape than the left edge. The angle of the line on the upper left shows where the thumb joins the base of the palm.

2 Add the wrist, thumb and a mitten-like guideline that will help you place the fingers. Note that the thumb bends at a 90° angle, crossing in front of the finger area.

3 Draw the details of the fingers, taking care to divide the mitten area into four equal parts. Indicate the knuckles in a neat line along the right edge of the sword hilt. Artists sometimes choose to make the contour of the index finger more pronounced than that of the other fingers.

4 Draw your sword of choice, making sure that the hilt stays exactly where you planned it to be. Ink the drawing. Let it dry, then erase the pencil lines.

Visit impact-books.com/masteringmanga2 to download a free bonus demonstration.

Foreshortening

Once you've learned to draw your character from the front, side and back, you'll want to move on to more challenging poses. When your story calls for a three-dimensional effect like an arm or leg stretching out toward the reader, foreshortening is just what you need.

The classic manga peace-sign hand is rendered to look like it's really reaching out of the page. It's a great way to begin your journey into the world of foreshortening.

1 Build Your Frame
Draw eight horizontal lines, equally spaced. You'll want them to be at least an inch or more apart to allow space for details later on. Draw your character's head (without hair) between lines 1 and 2.

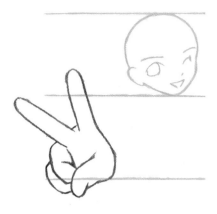
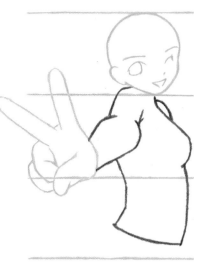
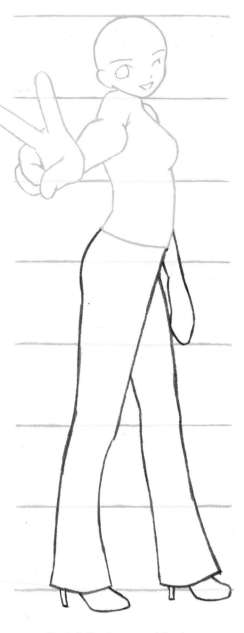

Create the Hand

Draw the peace-sign hand so that it overlaps lines 2 and 3. Take note of how far it is to the left. You'll need that blank space for the arm. Observe the structure of this particular hand. The thumb holds the last two fingers in place so that the first two fingers are free to extend. Foreshortening causes the hand to appear larger than the head.

Add the Arm and Torso

Add the arm and a rough indication of the torso. Foreshortening causes the forearm to appear larger than the upper arm. Notice the points at which the wrist joins the base of the hand. A glimpse of the far shoulder is visible.

Sketch the Legs and Feet

Add the legs and rough indications of the feet. This character is wearing jeans and high heels, but feel free to try something different. The hand on the right should emerge above line 4, and the fingers should touch line 5. In this pose, the knees fall right around line 6.

5 Add Details

Draw the hair, add details to the eyes, and put some wrinkles into the palm of the hand. No need to replicate this particular hairstyle; be creative and choose any style you like. A few clothing wrinkles will add a sense of realism no matter what type of clothes your character wears.

6 Fine-tune

Draw the other hand and add details to the clothing on the lower body. If your character is wearing pants, you may want to add some wrinkles around the waist and knees.

7 Finish It

Ink all the lines, let the ink dry, then carefully erase. If you take the time to add color or gray toning, experiment with making the peace-sign hand a bit more heavily shaded to add to the three-dimensional effect.

Extreme Foreshortening

If you really get into foreshortening, you'll find it can go way beyond a single hand popping off the page. Some poses consist of various foreshortening techniques coming together to create powerful three-dimensional effects.

Reaching Out

This character is reaching out at us, but he is also falling away from us in the sense that his left hand, and left foot especially, have been greatly reduced in size. The viewer gets the sense of a foreground, middle ground and background, all within a single pose.

Flying Away

Your story may call for a character diving into the heart of the action, and there's no better way to pull the reader in than by choosing an extremely foreshortened point of view. Here, one leg is all but concealed by the foot but it's not a problem. The viewer completes the picture in his or her mind.

Head Over Heels

The use of foreshortening is not limited to the realm of action-packed poses. This girl is mellow and relaxed, but the use of foreshortening livens up the pose and creates visual interest.

Arms and Hands

When it comes to drawing arms and hands, you really can't have too much reference. The more you study them, the better your understanding of their structure will be.

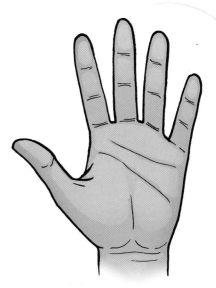

Open Palm

Study this pose to get the basic structure of the hand down before moving on to more challenging poses.

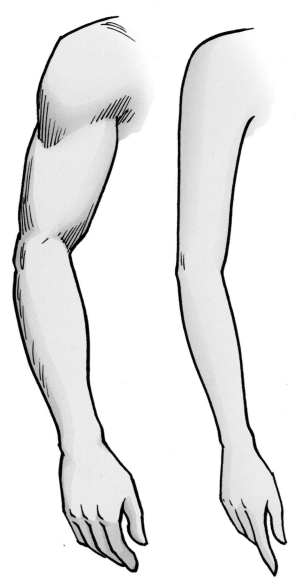

Male and Female Arms, Relaxed

Men's and women's arms are not that dramatically different from each other. But artists often accentuate the differences to make their male characters manly and their female characters feminine. In such cases, men's arms are angular with highly defined muscles, and women's arms are rendered with more subtle lines. Women's hands may even be reduced in size to make them appear more delicate.

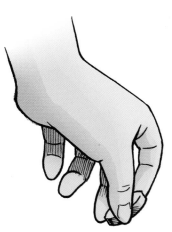

Picking Something Up

If your story calls for a character to pick up a small object, you'll want to use this drawing as reference. Note how two of the fingers are unneeded and stay out of the way.

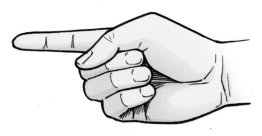

Pointing

The pointing hand can be quite a challenge to draw from memory. Note how the thumb holds three of the fingers in place.

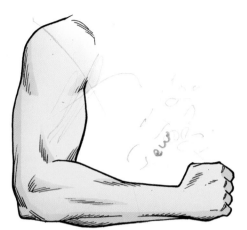

Male and Female Arms, Bent

When the male arm is bent at the elbow, the muscles may tense up and grow more visible. The lines across the forearm add a sense of realism. If your female character is meant to be athletic, you may add some muscle tone. If elegance is what you're going for, fewer lines are better.

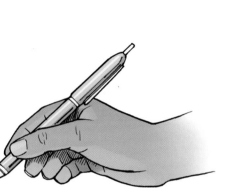

Writing

Different people hold pens in different ways, but artists generally go for a standard pose that doesn't call too much attention to itself. The pen is held in place by the thumb and index finger, while the remaining fingers are relegated to a supporting role.

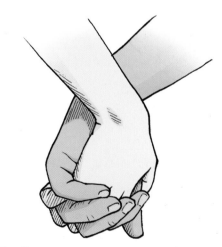

Raising a Glass

This is a difficult pose to draw. The thumb is greatly foreshortened. The glass is supported mainly by the first two fingers, allowing the pinkie to stay out of the way.

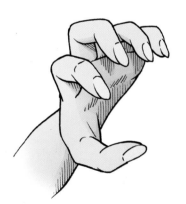

Grasping at the Air

Your story may sometimes call for a character to be reaching out in desperation or in pain. In such cases, each finger bends sharply at all three of its joints. Extra shading may be needed in the area of the palm to help convey the hand's structure.

Holding Hands

Drawing one hand is hard enough, so naturally drawing two hands intertwined becomes a special challenge. From this point of view her fingers are largely obscured by his, but the glimpses we catch of her knuckles are crucial to the drawing.

Legs and Feet

Legs and feet can be as challenging to draw as arms and hands. Feet present the added difficulty of often being tucked inside footwear. The various types of footwear all present their own challenges. Like anything else, though, it can all be mastered with practice.

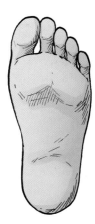

Sole of Foot

The foot is not as complex as the hand, but it is a rather difficult shape to commit to memory. The left side of this foot is more curved than the right side. Artists will sometimes exaggerate this curve to make the foot's shape visually clear to the viewer.

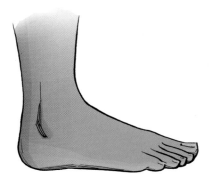

Foot in Profile

From the side, the foot has a sort of triangle shape, curving gently up into the ankle. The toes recede a bit from the big toe back to the little toe, each further back than the one before it.

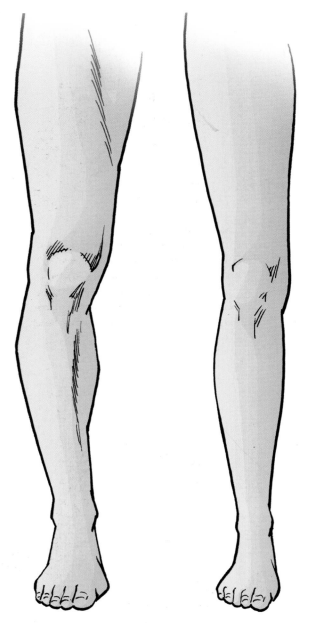

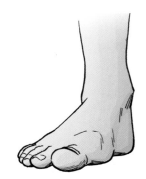

Male and Female Legs

The male inner thigh is sometimes depicted with lines that suggest a vertical group of muscles beneath the skin.

I have shown the female knee here as a more subtle version of its male counterpart, but many artists will render the female knee with just a light line or two and leave it at that.

Foot in Front View

This is one of the most challenging of all foot poses. One trick is to imagine the front part of the foot as a separate section and create a break in the contour to reflect that. The big toe is greatly foreshortened in this view, while the other toes are in more of a three-quarter view.

Footwear

It's hard to say which is more difficult— drawing bare feet or drawing shoes. Shoes are almost invariably more complex than the human foot in terms of the number of lines you must draw. On the plus side, shoes and boots offer a more defined structure that may be easier for an artist to commit to memory.

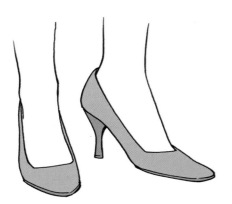

High Heels
When a high-heeled shoe is facing straight toward us, the heel itself is entirely obscured. Only in the three-quarter or profile view do we see the heel and how it connects to the rest of the shoe.

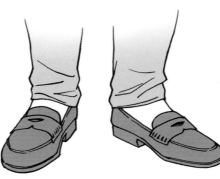

Loafers
This style of shoe is common in Japanese high schools, so you may need to master them if you're working on a classic high school romance story. The ridge that curves around the toe of the shoe makes it easier to draw, since you can begin to see how the pieces fit together.

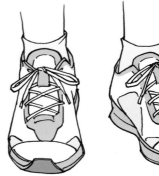

Running Shoes
Running shoes have long vexed me as an illustrator. The structure can be incredibly complicated. There is often a section near the front where the sole curves up around the toe. The lace section pulls together the two sides of the shoe so they are near each other but never touch.

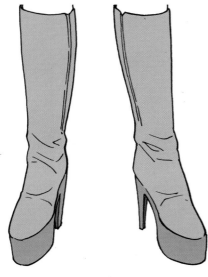

High-Heeled Boots
I think of these as "rock star" boots. Not only are the heels high but the entire sole is as well, elevating even the toe of the boot a good two inches off the ground. Boots like this will go all the way up the calf and may include wrinkles around the ankle.

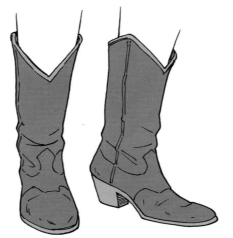

Cowboy Boots
Cowboy boots have a structure all their own and there is by no means only one type. Most will have a chunky heel that is only moderately high. The toe may come to a sharp point or one more rounded as you see here.

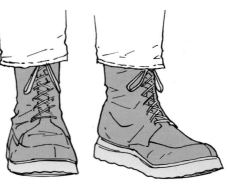

Work Boots
The lacing structure of work boots shifts up to the ankle and even higher. For added realism, get some wrinkles in where the leather pulls across the surface of the foot.

Visit impact-books.com/masteringmanga2 to download a free bonus demonstration.

16 Useful Poses

Here are 16 poses that you can use. Alter the details to turn them into characters of your own. Try tweaking certain parts, moving an arm here or a leg there to create entirely new poses.

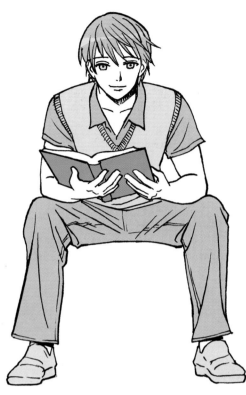

Boy With a Book

This pose involves foreshortening in the feet and the thighs. Adding wrinkles to the pants contributes a sense of realism.

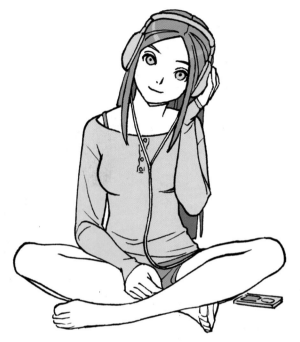

Cross-Legged

A cross-legged pose can prove surprisingly difficult when you try to draw it from memory. The key is to get the knees well up off the ground and to place the feet in their proper location.

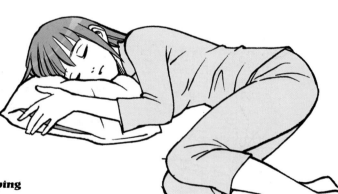

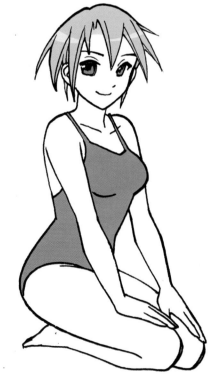

Sleeping

Bending the legs at the knees adds interest to this pose. Placing the feet at slightly different angles makes the pose look more natural than it would if they mirrored each other perfectly.

Leaping

The zigzagging quality of this character's legs brings a kinetic energy to the pose. The cape-like form of the jacket accentuates the feeling of movement.

Jumping

The poses on this page are all about movement. Artists will often make one leg straight and the other leg bent as a way of creating an interesting contour.

Cannonball

This pose makes use of foreshortening in the girl's right forearm. Again, the feet are differentiated to make the pose feel more natural and spontaneous.

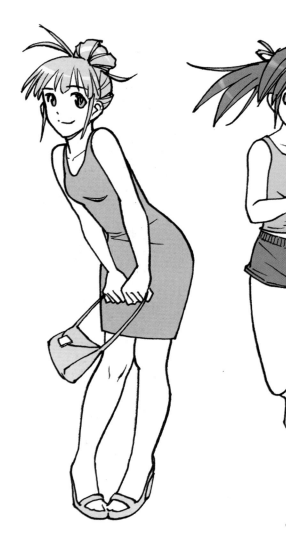

Girl Jogging

A running pose almost always involves one foot near the ground and the other raised in the air. The arms are both bent but to different degrees so that the hands point in separate directions.

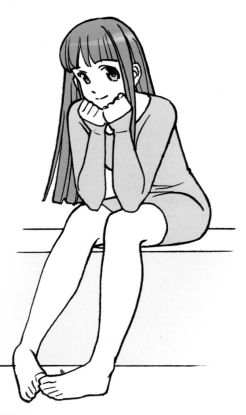

Girl Sitting

Here's a pose where the arms mirror each other quite closely. The toes pointing toward each other adds a cute touch.

Man With a Sword

Foreshortening comes into play again, this time in the character's right leg. The head turned away from the body creates drama.

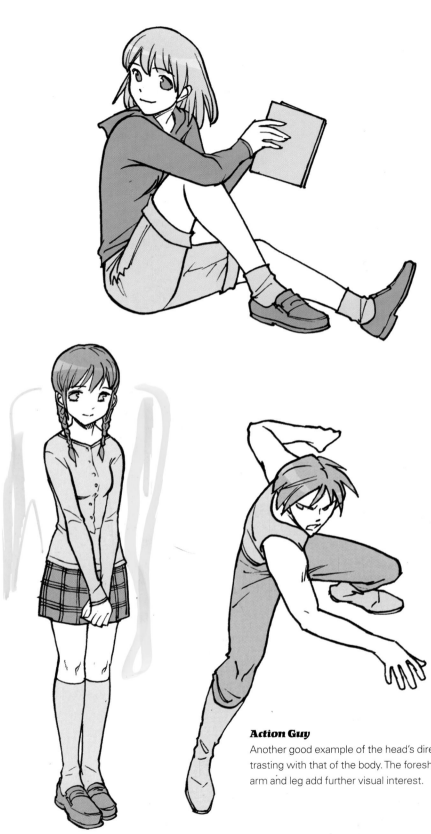

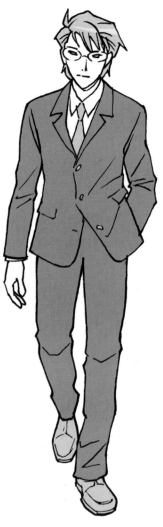

Businessman

Manga artists are fond of drawing characters walking straight toward the reader. In this pose the rear foot is usually pulled up so that only the toe touches the ground.

Action Guy

Another good example of the head's direction contrasting with that of the body. The foreshortened rear arm and leg add further visual interest.

Sitting Pose

A section of reference poses is helpful, to be sure, but sometimes you need someone to walk you through it step by step. So I've chosen three types of poses you can follow along with, line by line.

First up is a sitting pose. It's hard to imagine a manga story that won't include characters sitting at one point or another, so this is definitely a pose you'll want to learn.

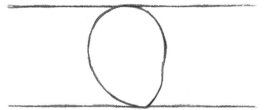

1 Build Your Frame

Draw six horizontal lines, equally spaced. You'll want them to be at least an inch or more apart to allow space for details later on. Draw the rough shape of your character's head between lines 1 and 2. In this pose the entire character is seen in a three-quarter view, so you'll want to get an indication of the cheek and chin on the right side of the head.

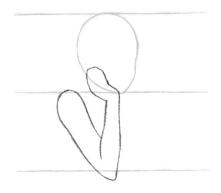

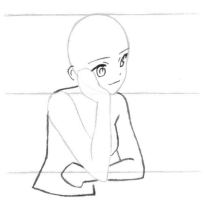

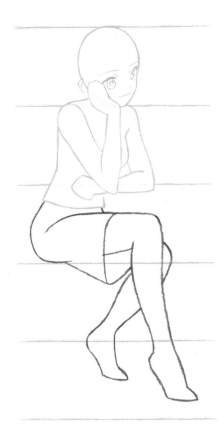

Sketch a Hand and Arm
Draw the arm and a rough version of the hand. The shoulder should rest upon line 2. The elbow should cross line 3. The palm of the hand should touch very near the chin. Make sure you get the proper width of the arm—wide at the shoulder and narrow at the wrist.

Sketch the Other Arm and the Torso
Add the facial features, the other arm and the torso. This arm will be resting on the table, so draw it bent sharply at the elbow with the forearm landing squarely on line 3. Remember that facial features become compressed on the far side of the face in a three-quarter view—thus the disparity in size between the two eyes.

Add the Skirt, Legs and Feet
Add the legs, a skirt and rough indications of the feet. The hips should rest upon line 4 while the ankles should be near line 5. This character will be wearing high heels, so depict the feet with only the toes touching the ground. As with the arms, it's important to get the width of the legs right—wide at the thighs, narrow at the ankles.

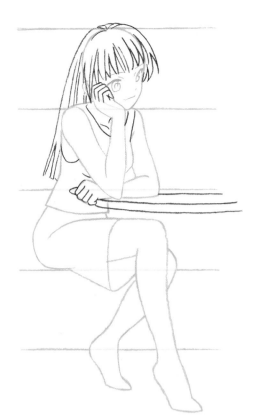

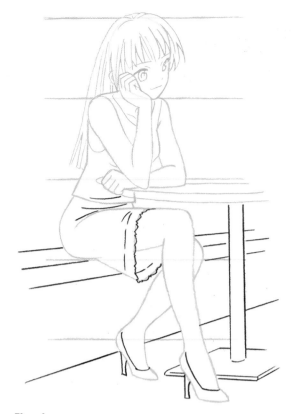

5 Add Details
Draw the hair, the hands and the table. No need to replicate this particular hairstyle; be creative and choose any style you like. Draw the hands lightly closed into fists so that each of the fingers line up neatly beside one another.

6 Fine-tune
Add details to the skirt and shoes. Draw lines for a bench and the bottom part of the table. If you'd rather she were wearing jeans—go for it: Just remember you'll want to add wrinkles at the knees and possibly the ankles as well.

7 Finish It
Ink all the lines, let the ink dry, then carefully erase. Add gray toning or coloring if you like.

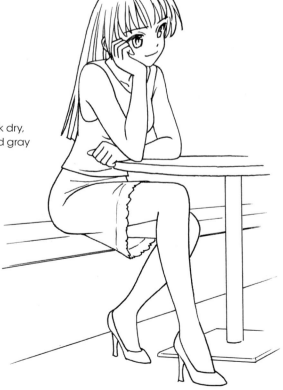

Various Sitting Poses

Everyone has his or her own way of sitting, and different seated poses can project different emotional states to a reader. A wise manga creator will always have a variety of sitting poses at the ready.

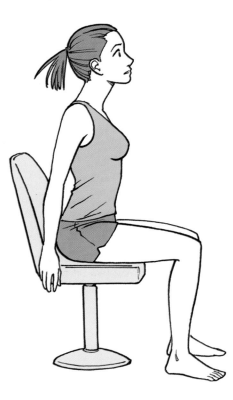

Alert

We're all supposed to sit up straight, but sometimes you'll want your character to take this a little too far to show how nervous or startled she is. The arms are very far back from the rest of the body, and the knees are bent at a 90° angle. This pose has an "I didn't think the teacher would call on me" feel to it.

Crestfallen

Here we go to the opposite extreme. Our character is slumped over with her legs tucked back under her. This pose suggests introspection or even a depressed mood.

Cross-Legged

The more relaxed sitting poses involve characters crossing their legs, usually in one of two ways: ankle upon knee, or knee upon knee. The trick with these poses is to get the angle of each leg right. The man's crossed leg is raised a bit at the knee so that it is not perfectly horizontal. The woman's leg is tilted a touch so that it is not perfectly vertical.

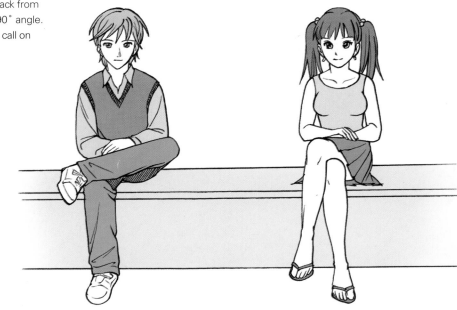

Visit impact-books.com/masteringmanga2 to download a free bonus demonstration.

Fighting Characters

Nothing says action like a fight scene. When characters come to blows in your manga story, you will be put to the test as an artist. All your studies of anatomy and proportions must come together so that you can deliver a knockout scene to your readers.

This lesson will show you how to draw the guy throwing the punch, as well as the unlucky fellow on the receiving end of it.

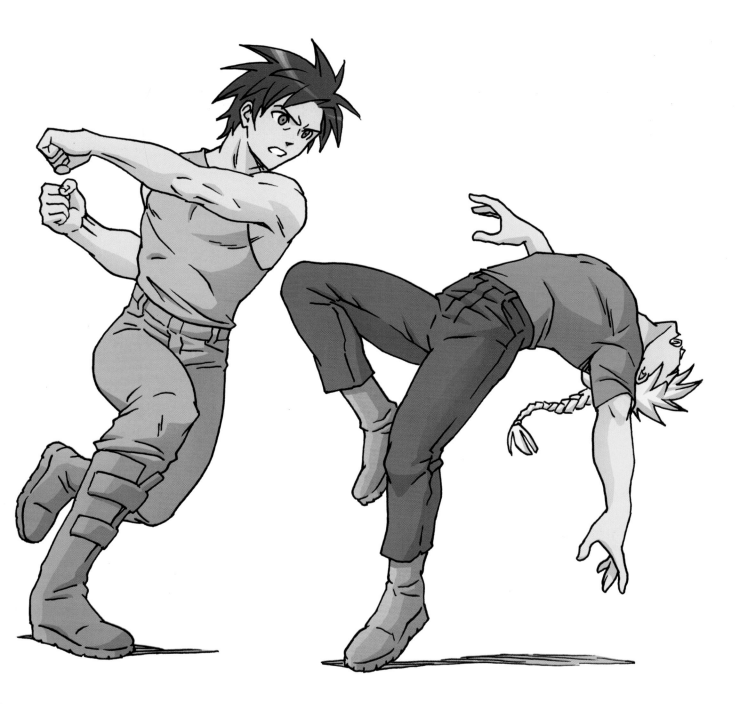

1 Build Your Frame and Sketch the Heads and Torsos

Start with two diagonal lines that form a sort of funnel shape, narrow on the right and wide on the left. Sketch in the rough forms of the heads and torsos of your characters. The distance between them is key—if they are too close to each other, you'll run into trouble later on.

2 Add Arms and Hands

Draw the arms and rough indications of the hands. Make the arm that has just thrown the punch straight, stretching across his torso from right to left. The arm of the other guy should also be straight, but fall vertical as he receives the impact of the blow.

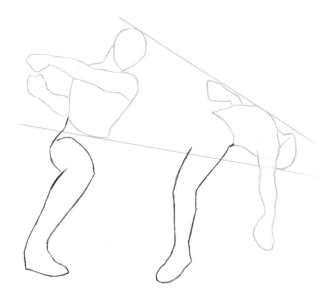

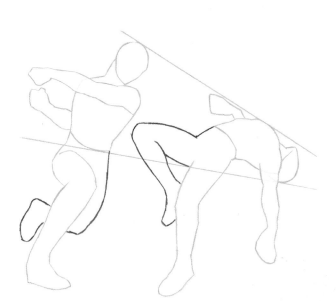

3 Sketch One Leg for Each

Add one leg for each of the characters. The leg on the left should be bent at the knee and slightly foreshortened in the thigh. The leg on the right should be only slightly bent, with the heel of its foot up off the ground.

4 Add the Other Legs

Sketch the other legs on each body. The leg on the left should be off the ground to suggest forward momentum. The leg on the right should be bent more severely, adding to the sense that this character has entirely lost his balance.

5 Detail the Punching Character

Add the details to the character on the left. Take your time with the hands and the face—the placement of those lines is crucial. The hair and clothing wrinkles can be added in a looser way, substituting your own clothing choices for mine.

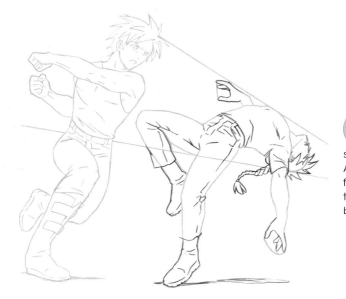

6 Detail the Receiving Character

Add the details of the other character. I've chosen to give him a ponytail, but you should give him any hairstyle you like.
As with the other figure, the placement of the fingers and facial features is more important than the details of the clothing. Add a drop shadow beneath his body to complete the image.

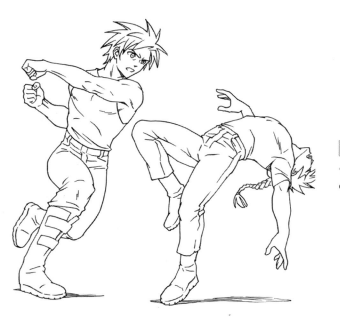

7 Finish It

Ink it up, let it dry, and erase the guidelines. You can add gray tones or color to finish it off if you like.

Action Poses

Hands can sometimes say almost as much about your character as the face does. However, not all hands look alike. Use this page for ideas on how to make some of your characters' hands more distinctive.

Running Girl

One common strategy with action poses is to have the head facing in a different direction from the torso. In this pose, the arm and leg are bent on one side of the body and are straight on the other, creating a visual balance between the two sides.

Brandishing A Sword

What makes this pose work is the stance. The widely spaced feet allow him to cut a bold figure, one that clearly will never run from a fight. The cape serves as a decorative element, one that balances out the other parts of the drawing.

Running Man

Here we see the opposite approach: The bent-arm and straight-arm configuration of the upper body is reversed when we move down to the legs. The end result is a different form of visual balance, just as effective as the other.

Standing Kiss

Love stories have been a staple of manga storytelling from the start. When your story's big romantic moment has arrived, you'll want to be sure you can render it just right.

While the kiss itself is challenging, the standing pose that accompanies it presents difficulties for the artist as well. Follow this lesson step-by-step to draw a standing embrace that embodies the perfect kiss.

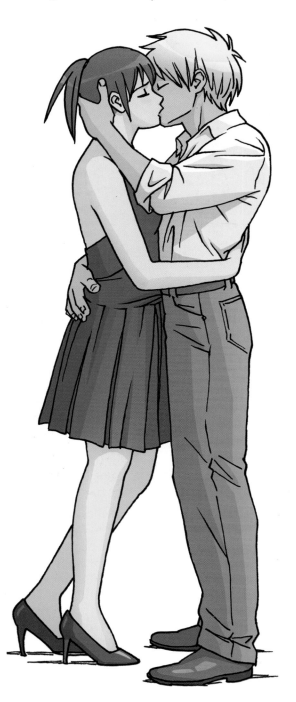

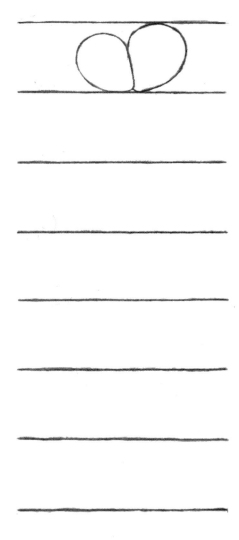

1 Build Your Frame

Draw eight horizontal lines, equally spaced. You'll want them to be at least an inch or more apart to allow space for details later on. Draw your character's heads (without hair) between lines 1 and 2. Her head should overlap his head ever so slightly.

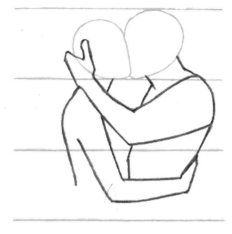

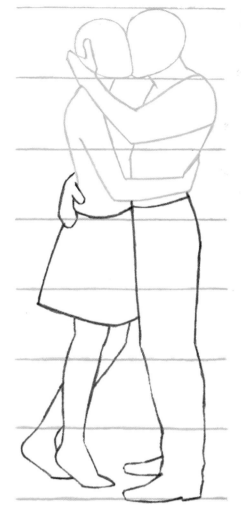

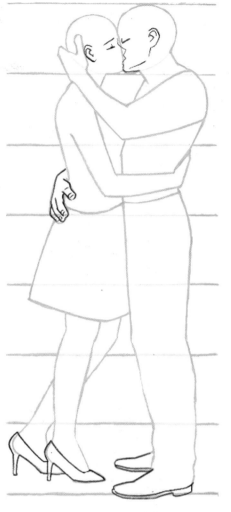

2 Sketch the Arms, Hands and Torsos

Draw the arms, upper bodies and rough indications of the hands. His arm should fall mainly between lines 2 and 3, and hers should be mostly between lines 3 and 4. The angle of each arm at the elbow should be slightly more open than a 90° angle. Make her arm somewhat uniform in width, and make his arm much wider in the upper portion.

3 Add the Legs and Feet

Add his other hand at her waist, then draw their legs. Both of their knees should be just above line 6. Have her lower legs cross at the calves. Replicating the tiny pocket of space between her ankles may help you get her feet in the right place.

4 Define Facial and Clothing Details

Draw their facial details, his right hand, and both of their shoes. When drawing the faces, make sure that her chin is behind his, while her upper lip and everything above it is in front of the corresponding features on his face. Comparing the locations of their eyes and ears may help you get all these lines in the right place.

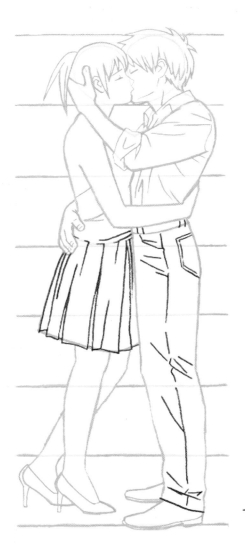

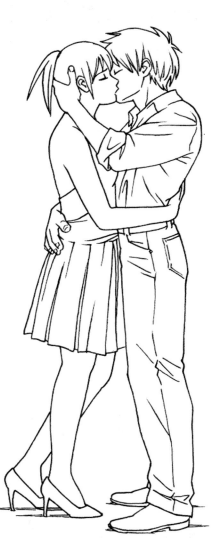

5 **Continue Adding Details**
Add the details of the hair and the upper body clothing. The hair and clothing wrinkles can be added in a looser way, substituting your own hair and clothing choices for mine.

6 **Fine-tune**
Add the details of her skirt and his pants. Adding clothing wrinkles in the areas of his waist, knee and ankle will contribute a sense of realism.

7 **Finish It**
Ink it up, let it dry, and erase the guidelines. You can add gray tones or color if you like to finish it off.

Romantic Reference

If you're serious about creating manga love stories, you'll need a wide variety of romantic poses for your characters. Use these illustrations as reference and inspiration when you sit down to invent poses of your own.

Leaning In for the Kiss
The moment before a kiss can be just as romantic-looking as the kiss itself. Her hand clutching his jacket adds to the drama of this pose.

Hugging From Behind
If you need to draw a form of embrace that keeps both of your character's faces fully visible this pose is a good choice. The different angles of her forearms create visual interest.

Relaxing Together
Here's another nice pose that allows us to see the characters together while also keeping their faces visible. The arms and legs crossing in front of one another tie the drawing together in a pleasing way.

Clothing

Once you've learned your character's body proportions you're ready to figure out what they're going to wear. It's impossible to cover all the different costume choices in just a few pages, but we can certainly make some useful observations about drawing clothing and using it to convey character.

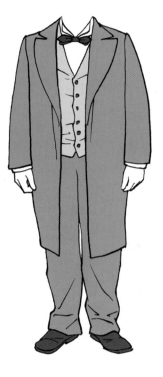
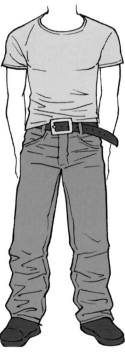

Men's Clothing: Past vs. Present

It's fascinating to see how much clothing has changed over the years. If you're working on a Steampunk story set in the nineteenth century, you'll need to familiarize yourself with the clothing of the period. Note how modern clothing's emphasis on comfort results in many more wrinkles being made visible.

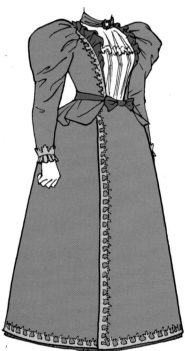
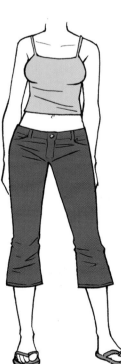

Women's Clothing: Past vs. Present

For women, the clothing changes between past and present may be even more dramatic. The entire contour of the illustration has changed, as the clothing went from a concealing approach to a revealing approach. There's no question that deciding to set your story in the past will require careful study to deliver authenticity.

Clothing Folds

Different fabrics produce different wrinkles. Consult this page for guidance if you're having trouble drawing the wrinkles on any number of clothing types.

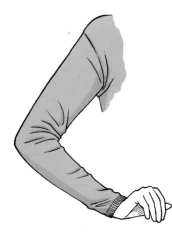

Light Sweater

This sweater is quite snug as it fits the form of the body beneath it. The wrinkles are numerous and tightly packed.

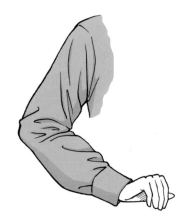

Dress Shirt

Here the clothing is much looser. The wrinkles are still large in number but they are more widely spaced.

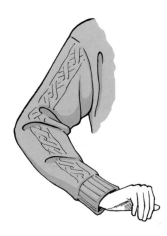

Thick Sweater

A heavy sweater produces only a few wrinkles, and they are widely spaced. A banded cuff like this one is my go-to device for making an article of clothing read as a sweater.

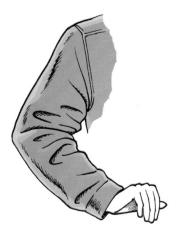

Leather Jacket

Here the wrinkles are rounded and some-what widely spaced. The thickness of the material means that it conceals much of the body beneath it.

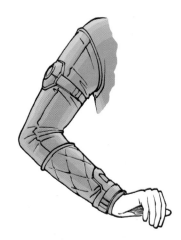

Futuristic Jacket

If you have set your story in the future you may want to create costumes entirely out of your own imagination. Even so, including wrinkles and seams can bring an added sense of realism.

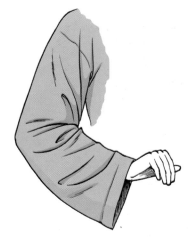

Robe

Whether it's medieval times or a modern-day character after a bath, a robe hangs very loosely and creates long, flowing wrinkle lines. Mixing in some shorter lines with the longer ones helps to complete the effect.

Clothing Styles

Clothing is a huge part of conveying your character's personality. If all your characters are dressed similarly or in a somewhat generic manner, you owe it to yourself to dress them up in a way that says a little more to the reader about who they are.

Beach Comber

Pretty much the same guy, and yet he couldn't be more different. The hat, the cut-offs, the sandals and untucked shirt all say, "I'm on vacation—permanently."

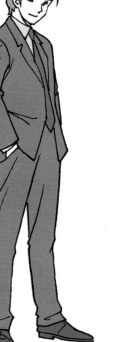

Businessman

Let's start with an average "everyman" character—a guy in a suit. We have some sense of his place in the working world but not much else.

Goth

A change in hairstyle has entered the mix, but the clothing choices are just as important in conveying this guy's love of the dark side. The boots and long coat create an imposing silhouette.

Renaissance

Maybe your story is set in a fantasy realm that calls to mind Europe of ages past. Rather than just winging it with the clothing, consult illustrations of period dress to give your characters an air of authenticity.

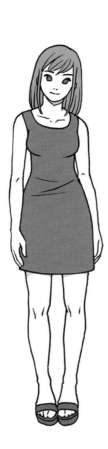

Plain Jane

There's nothing wrong with this drawing, but we don't come away from it knowing very much about her as a person.

Casual

Even without going to the extremes of straw hats and flip-flops, we get a much more relaxed vibe from this character. We imagine she likes things in her life to be natural and unpretentious.

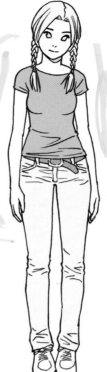

Goth

A female goth character has more clothing options than her male counterpart, such as the mesh sleeves and striped leggings. Dress your character like this, and the reader will know she walks to the beat of a different drummer.

Renaissance

People in earlier centuries clearly placed great value on what they wore. If you've decided to evoke such clothing in your story, pay attention to the details. The people of that time certainly did.

Chibis

Just because you've become serious about body proportions doesn't mean you can't cut loose and go chibi style every once in a while. Here are some chibi versions of people from different walks of life that may inspire you as you devise chibi characters of your own.

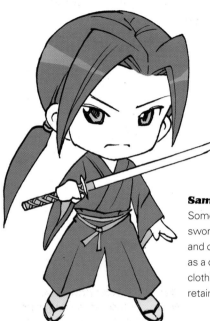

Artist
Sure, the French "arteest" with a beret is a total stereotype. But the chibi style was never meant to be very subtle. It's all about exaggeration to make a point.

Samurai
Somehow even a dangerous swordsman becomes cute and cuddly when rendered as a chibi. Note that the clothing, while simplified, retains authentic details.

Nurse
Cute nurse characters are a long-standing manga tradition. Any profession associated with a uniform remains easily recognizable in chibi form.

Full-Sized to Chibi

Manga artists often draw chibi versions of full-sized characters, which readers can instantly recognize as the same character in pint-sized form. Here you can see the ghost character, Talia, from my *Brody's Ghost* graphic novel series in both full-sized and chibi form. Follow the steps to gain a sense of how I changed her from one form to the other.

1 Build Your Frame and Sketch the Head and Torso
Start with two horizontal lines, equally spaced. Make them at least two inches away from each other to allow space for details. Draw the chibi head between lines 1 and 2. Pay attention to how large the eyes are and where they are located on the head. Make the eye on the left smaller because her head is slightly turned away from us. Draw the torso, which is so small it doesn't even reach halfway to line 3.

2 Detail the Hair and Face, Indicate the Arms and Legs
Draw the details of the hair and face, as well as rough indications of the arms and legs. This hairstyle is specific to my character. If you'd like to use this lesson for creating one of your own characters, reproduce that character's hairstyle in a similar way. The feet should extend just beyond line 3.

3 Add Clothing
Add the clothing details. Because the body is so small, you would find it very hard to squeeze in every detail from the full-sized version. That's why manga artists deliberately simplify the clothing and include only the essential details, jettisoning the rest.

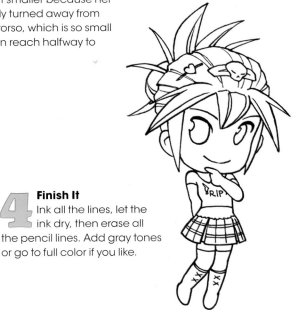

4 Finish It
Ink all the lines, let the ink dry, then erase all the pencil lines. Add gray tones or go to full color if you like.

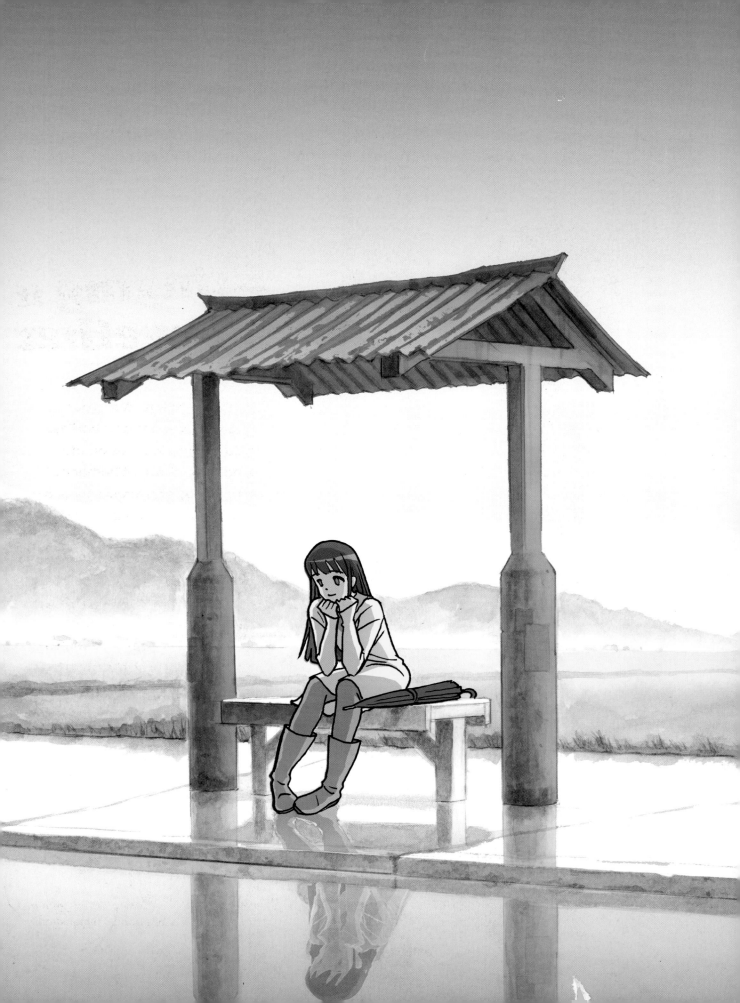

Bringing it all Together

You know how to draw your characters' faces and bodies. Now it's time to focus on the land they inhabit. Whether it's a rainy day or a forest scene, a good manga artist is ready to deliver illustrations that bring readers into the world of the story.

But that's just the beginning. The real joy of all this comes when you take the skills you've acquired and pour them into the actual panels and pages of your manga. Trust me, the best part of your journey as a story-teller is yet to come.

Visit impact-books.com/masteringmanga2 to download a free bonus demonstration.

Perspective

In the first *Mastering Manga* book, there is an extensive section on the various types of perspective. This time we'll be focusing on backgrounds that are more organic and less reliant on perfectly straight lines. Still, let's go through the basics of one-point perspective since it is essential in rendering backgrounds.

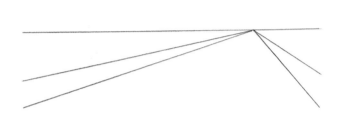

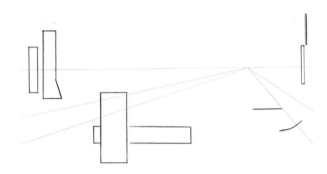

1 Establish the Horizon and Vanishing Point

Use a ruler to draw a horizontal line from left to right. This is the horizon line—that place way off in the distance where the earth meets the sky. Put a point on that line a good deal closer to the right than the left. This is the vanishing point. Use the ruler to draw a couple of straight lines coming off the vanishing point all the way to the lower left and lower right corners of the drawing.

2 Draw Object Surfaces

Draw some rectangles in various places. These are the surfaces of various objects. For now we can see only the surface that is facing us directly. On the right side you see lines rather than rectangles. These are panels that have no surface facing us, but in the next step they will have a surface that recedes from us.

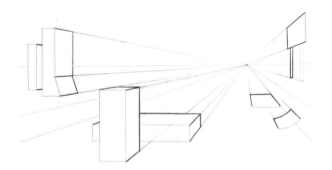

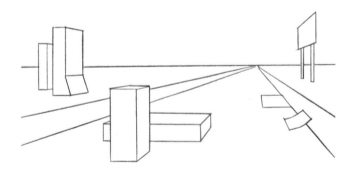

3 Create a Three-Dimensional Effect

Make sure that part of your ruler's edge is directly touching the vanishing point at all times and draw diagonal lines off the corners of all the rectangles you drew in step 2. Once you've done this you can draw the various horizontal and vertical lines that close off these lines and give the appearance of transforming the flat rectangles into three-dimensional objects. Those right-side lines from step 2 now appear to be panels and a billboard; three dimensional but not possessing much mass.

4 Finish It

Erase the pencil lines you no longer need and you're finished! If you are careful in mastering this lesson, you will be able to make use of it as part of one of the more detailed environment lessons ahead.

Tree

Drawing a tree is something every child does almost as soon as he or she can pick up a crayon. As you grow older you come to appreciate how challenging it is to draw them realistically. Follow the steps to draw a tree that is more convincing than what you might have done as a child.

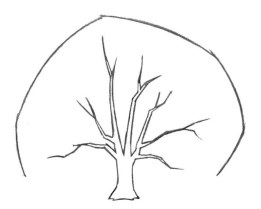

1 Create a Line Drawing
Sketch in a line that is a rough half circle. Below it draw the trunk and four or five of its most important branches. Each branch should reach toward a different area. Make a couple vertical while others go fully horizontal. In real trees the branches divide dozens of times, but at this stage you may simplify things by having them divide only once or twice.

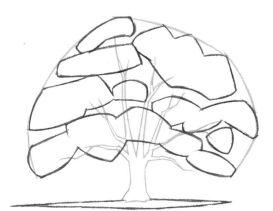

2 Break the Large Shape Into Smaller Shapes
Break the half-circle into various smaller shapes. Place them in such a way that you obscure parts of the branches you drew in step 1, leaving other parts exposed.

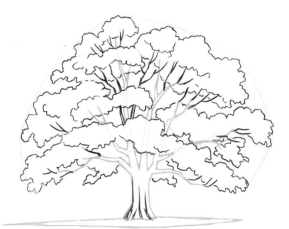

3 Refine the Details
Take the shapes you drew in step 2 and refine them further. It is not necessary to draw each and every leaf. You need only suggest masses of leaves by way of a jagged irregular contour. For added realism, draw additional small branches here and there at the extremities and define the trunk a bit more at the base.

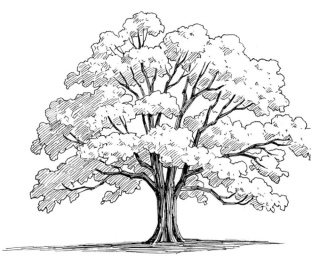

4 Finish It
If you are confident in your inking skills, move straight to pen at this stage. Add shading to the left side of the tree and darken the trunk. Add a large shadow on the ground to provide a nice finishing touch.

Forest Background

If a single tree is hard to draw, then a forest may seem a near impossible task to one who wishes to capture it in all its detail. Happily there are ways of establishing a deep woods setting without having to render every last twig and blade of grass.

Follow the steps to draw a nicely detailed forest backdrop that will serve you well next time your story demands one.

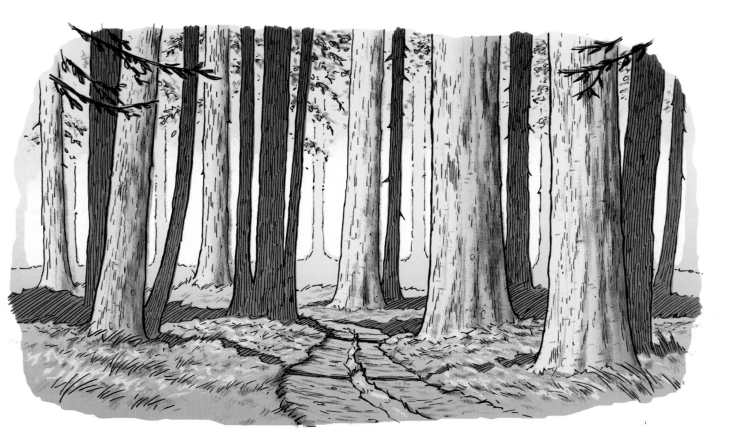

Create a Line Drawing

1 Draw a few of the most important tree trunks in what will be the middle ground of your illustration. I chose to split one into smaller trunks for variety's sake. Next, draw a slightly wavy line behind the tree trunks. This will eventually serve as a border between the middle ground and the distant background. Finally, draw a winding road in the middle. Try rendering the perspective of this road in an instinctual way, rather than relying on rulers and vanishing points.

Add More Tree Trunks

2 Now you can add some secondary trunks to expand your group of trees into a full blown forest. The ones in the distant background should all be fairly narrow from side to side. Draw a series of horizontal shadow lines across the forest floor. You can focus on having each shadow line up with a particular tree, but you can also get away with treating these shadows in a more decorative way by using them to pull the drawing together, rather than obsessing over the physics of it.

Begin Shading

3 Add shading to selected trees in the middle ground. This is largely a matter of personal preference. If you prefer this block of shadow to be in the foreground or deep background you can create equally pleasing arrangements that way. The main thing is to try to organize the darker areas into some discernible pattern rather than having your scene shatter into a random patchwork of darks and lights.

4 Add Details

Add final details to the tree trunks and to the forest floor. If you have drawn a road you'll want to suggest a flatter, more even texture to this surface. This drawing is more simple than it would have been had you included more branches, but you will want a few of them within the frame. Here, I confined them to the upper corners and the distant background.

5 Finish It

Ink all the pencil lines. As you gain experience as an inker, you will be able to improvise a bit of texture in the tree trunks and elsewhere without having to plan every jot in pencil first. Gray tones and color will help to add even more depth to the image.

Elements From Nature

There is no end to the number of things you'll need to learn to draw if you want to become a master of backgrounds. Here is some advice on drawing three common elements that are often required when one sets a scene in the natural world.

Rocks

If your characters have climbed high into the mountains or gone deep into a cave, the background becomes an ongoing expanse of stone. Inking your lines so that they follow the surface of the rock will help convey a feeling of solidity to the reader.

Grass

You may find that you are still rendering grass much the same way you did in grade school—as a series of undifferentiated vertical lines. This gets the job done, of course, but why not challenge yourself to draw grass in a wilder state? Interspersing taller blades with smaller leafy plants will bring greater authenticity to any grassy scene.

Rivers

Rendering water with inked lines requires a bit of artistic license because you are imposing lines where there are none in real life. Adding rocks to a river is a nice way of breaking things up and bringing structure to what might otherwise become loose and messy looking.

Rain

Nothing brings drama to a story quite like rain. It's hard to think of a manga series that hasn't used rain at one time or another to make a scene more atmospheric or visually striking. Follow this step-by-step lesson to learn the tricks of the trade for adding a bit of inclement weather to your story.

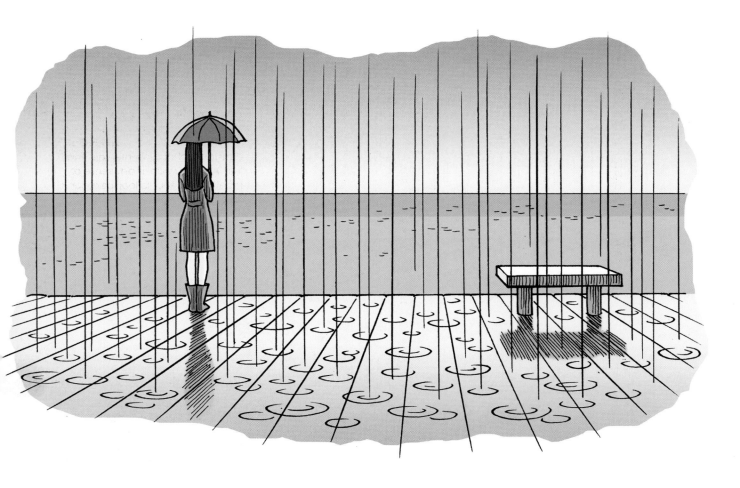

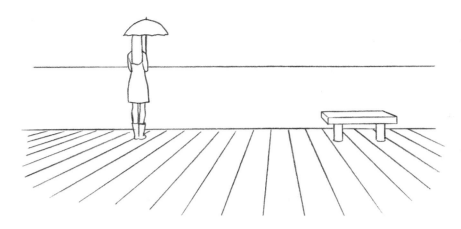

1 Create a Line Drawing

Using a ruler and your knowledge of one-point perspective, draw a horizon line. Below it, draw a dock-like surface composed of diagonal lines, each heading toward the vanishing point. Add a bench near the edge of the dock, taking care to make its lines head toward the vanishing point as well. I have added a figure with an umbrella, but feel free to draw anything you like in her place, or simply leave that space empty.

2 Add Vertical Lines

Using a ruler, add vertical lines of various lengths spaced at constantly changing intervals. The last thing you want is any sense of repetition—it should look as organic as possible.

3 Draw Ripples

Add small oval shapes across the surface of the dock to convey ripples where the raindrops land. These also need to arranged in a random way, with small ovals beside large ones. There should be no discernible pattern to the way you've arranged them.

Visit impact-books.com/masteringmanga2 to download a free bonus demonstration.

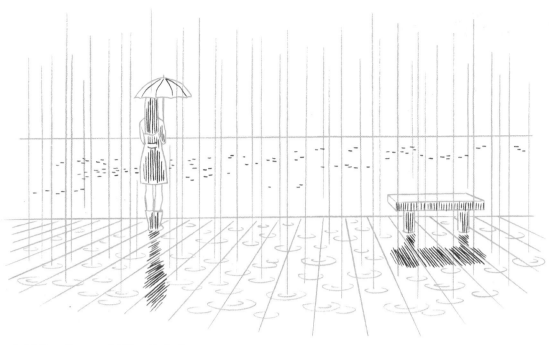

4 Add Shading and Other Details

Shade the bench and the figure, if you have chosen to include her. Render reflections upon the surface of the dock using your preferred method of shading. I chose to have my lines follow the surface of the dock, more or less receding toward the vanishing point, though not to the degree of using a ruler to draw them. I also added some detail to the surface of the sea, just a finishing touch and not necessarily related to the rain.

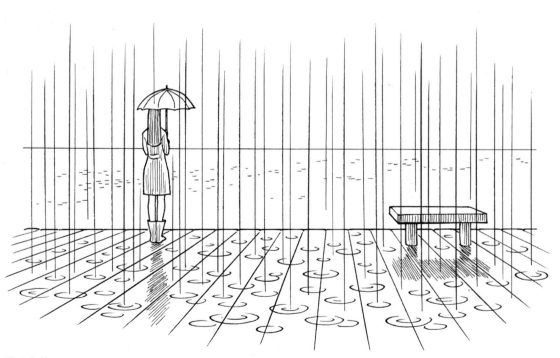

5 Finish It

Ink the drawing, let it dry, then erase all the pencil lines. Adding gray tones or color will go a long way toward completing the rainy-day effect.

Water Effects

An artist is often called upon to convey the sense of an object being wet or dry, even if it's just a matter of being consistent—you can't have characters standing out in the rain looking like they're completely dry. Here are some tips for conveying water effects in your illustrations.

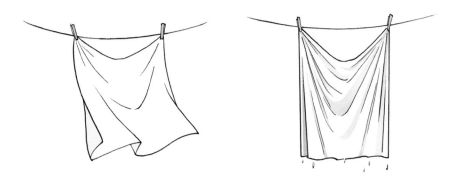

Towel on Clothesline

Often times an artist is unable to actually draw water on the surface of the object and so he or she must suggest its presence or absence by other methods. The dryness of the towel on the left is suggested entirely by the flowing lines of it flapping in the breeze. The dampness of the towel on the right is of course conveyed by the falling droplets of water, but the largely straight lines of its form also contribute to the effect.

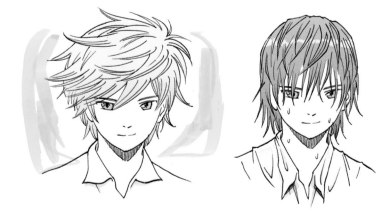

Hair

The curving lines and full-bodied shape convey fluffiness here. With a light-haired character you can refrain from dark tones in the hair to suggest dryness. The collar of his shirt is also rendered with curving lines.

As with the wet towel, wet hair is brought down flat by virtue of its own weight. All the strands of hair become quite vertical and may even appear a bit tangled. If adding a highlight is an option, wet hair calls for a very sharp one: pure white against a darker color above and below. The lines of the shirt have become more angular and disheveled looking.

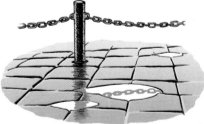

Ground Surfaces

Here we see the same outdoor area in dry weather and wet. The lines of the stonework have many breaks in them in the dry version while they are bold and black in the wet version. Reflections of objects, not just in the puddles but on the stonework itself, are perhaps the single most effective way of showing that a surface is wet.

Post-Apocalyptic Desert

A desert certainly has its advantages as a place to set a story: Every scene immediately has a sense of stark drama to it, all the while saving you from the chore of drawing trees! This lesson shows how the objects you created in the one-point perspective lesson can be placed into an actual environment, one that is otherworldly but also grounded in reality.

1 Create a Line Drawing

Start with the one-point perspective scene. If you'd like to make it your own, try moving objects around or inventing entirely new structures. It's probably best to stick with the single vanishing point though, if you are new to more complicated perspective schemes.

2 Add Mountains in the Background and a Figure in the Middle Ground

Sketch a couple of jagged lines at the horizon line, one resting upon it, the other a little above it, to create a distant mountain range. I've chosen to add a futuristic structure beyond the mountain range. Feel free to skip it, or to invent a different structure in its place. I've also added a lone figure in the middle ground and a few more lines to define the road-like structure that stretches out toward us.

3 Add Details

Add surface detail to the mountain range, the edges of the road, and throughout the illustration. Scattered pebbles in the foreground help to give solidity to that area, while various lines upon the desert middle ground make the area's surface more varied and visually interesting.

4 Fine-tune

Add shading to the upper edge of the mountain range and to some of the terrain in the middle ground. Small tufts of desert grass are a great way of conveying distance: With larger ones close and tiny ones in the distance the eye uses them to gauge how far away various parts of the setting are.

5 Finish It

Before inking, consult the lesson on weathering objects to change the simple block structures into the damaged remnants you see here. Once you've got everything the way you want go over all the lines with ink. Let it dry, erase the pencil, and leave as is or add coloring.

Surface Detail

A manga artist is often called upon to create the illusion of various surfaces, showing that different items are composed of different materials. Here are four such objects, each accompanied by tips on how to draw them.

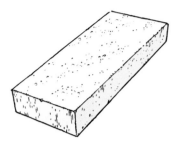

Wood

Including at least one oval knot in the surface is the key to suggesting wood. Draw two or three stretched-out ovals around a dot then straight lines that surround it on either side.

Concrete

To convey this sort of stony surface, create a random arrangement of very small dots interspersed with larger ones. Leave some areas blank so as to keep it from being too regular a pattern.

Chipping Paint

If you observe actual chipping paint you find that it cracks into little squarish subsections before falling off. For an added touch render a bit of the wooden surface below.

Rusting Steel

This bears some similarities to concrete but with more of the surface left blank. Adding rivets guarantees readers will see this as a piece of steel.

DRAW WEATHERED OBJECTS

Follow these steps to make a simple object appear broken and weathered.

1 Begin with a rectangular cube, following a one-point perspective for added realism.

2 Remove an irregularly-shaped section of the top, creating texture in the broken area by way of dots and dashes.

3 Draw lines, dots, and half-circles in a random arrangement across the remaining surfaces. Vertical streaks give an added sense of decay.

4 Ink, let it dry, then carefully erase the penciled lines.

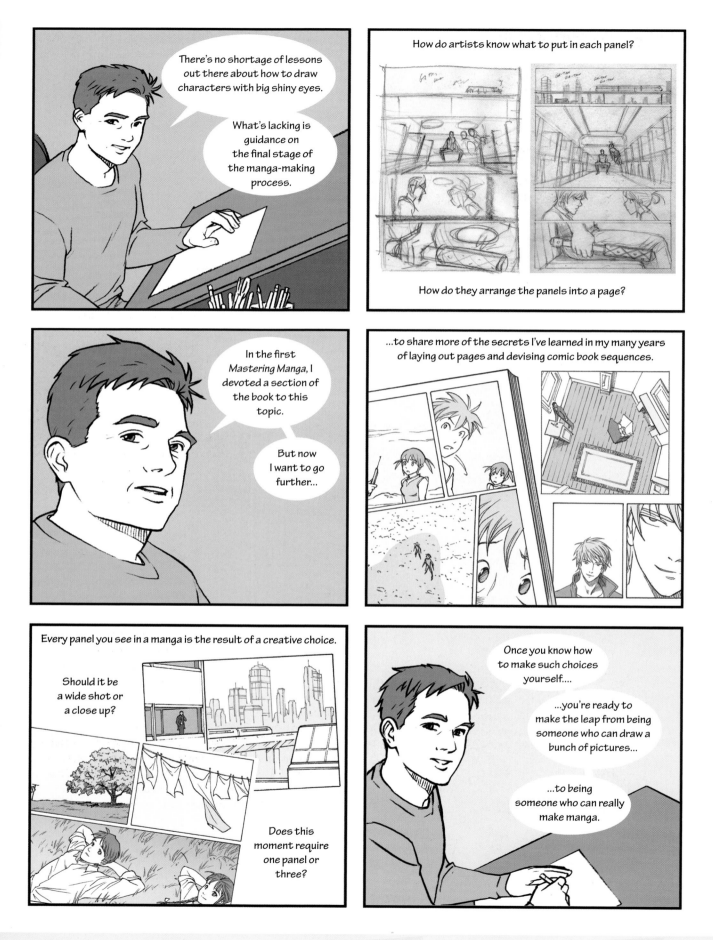

There's no shortage of lessons out there about how to draw characters with big shiny eyes.

What's lacking is guidance on the final stage of the manga-making process.

How do artists know what to put in each panel?

How do they arrange the panels into a page?

In the first *Mastering Manga*, I devoted a section of the book to this topic.

But now I want to go further...

...to share more of the secrets I've learned in my many years of laying out pages and devising comic book sequences.

Every panel you see in a manga is the result of a creative choice.

Should it be a wide shot or a close up?

Does this moment require one panel or three?

Once you know how to make such choices yourself....

...you're ready to make the leap from being someone who can draw a bunch of pictures...

...to being someone who can really make manga.

My Process, Start to Finish

When you flip through a manga, the finished pages look so polished and clean that it may seem astonishing to you that anyone could have just sat down and drawn them. Well, they didn't—not all in one step, anyway.

I want to demystify the process by showing you one page from my *Brody's Ghost* graphic novel series and taking you through every step in its creation.

The Words

I always begin by working out my pages in written form on inexpensive paper. This is especially important if it is a page with dialogue. If you have a rough idea of the dialogue in advance, you can plan the panels to deliver the word balloons in the best way possible.

Notice how I crossed out and rewrote some parts. My self-editing process has only just begun. In the following pages, you'll see that I refined the conversation in the word balloons again and again on the way to the final page.

The Thumbnail

I've started to envision the scene and have broken it down into four moments, each with its own panel. The first panel shows us that the characters are on an elevated train. The second panel brings us inside to see Brody and the ghost, Talia, talking to each other. In the third panel, a closer view from a different angle allows us to see facial expressions more clearly. Finally, the close-up of Brody's mace-like weapon reveals he's prepared for a fight of some kind.

Because it's so loose at this stage, I can play around with possibilities without committing too much time to anything. In this case, the first panel determines the layout for the page. The exterior shot of the train required a very wide horizontal panel, and panels 2 and 4 also seemed like they would be best served by a horizontal orientation.

Visit impact-books.com/masteringmanga2 to download a free bonus demonstration.

The Rough

Now I've moved on to something with a little more detail. I'm still working on cheap paper at this point, as it's preparatory work and can't be used as final art. I'm starting to envision each panel's details a little more clearly. In the thumbnail version, I made all four panels about the same size. In this version, I made choices as to which panel deserved the most space.

Panel 1: Narrow, because the image doesn't need that much space and there's only a single word balloon.

Panel 2: Extra large, because I want to establish the interior of the train in the reader's mind. I also know Talia will have several word balloons in this panel and I want to make space for them.

Panels 3 and 4: These two panels serve as a kind of one-two punch. Brody begins his sentence in the third panel and finishes it as we cut to the shot of his weapon in panel 4. Again I made a choice as to which panel deserved more space.

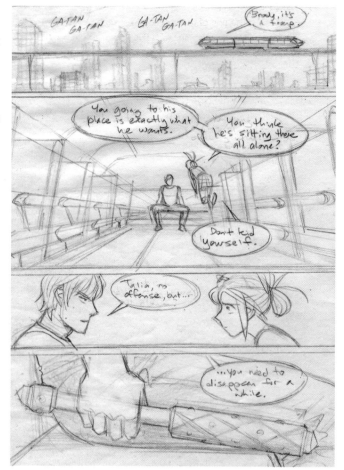

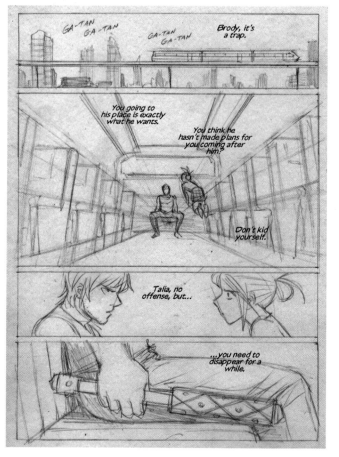

Final Pencil Lines

Now I have moved to a sheet of smooth bristol and am putting down pencil lines that I intend to ink later on. I still have not made the artwork very detailed at this point, because I will be showing this page (along with all the others) to my editor at Dark Horse Comics, and there may be changes requested. I want to make sure it's fully approved before I tighten up the pencil lines and start inking.

If you compare the words that Talia says in the second panel to what I wrote earlier, you will find that it's different from both the first and the second stage. And in the next stage it changes yet again. A storyteller is constantly reevaluating what needs to be conveyed to the reader and which words do the best job of conveying it.

Extra credit: Do you see where I used one-point perspective?

Final Inks

We're nearing the end of the process. The editor has approved the page, and now I can ink it. Because the pencils in the previous stage were done on bristol board, I can ink right on top of them and transform them into final artwork.

The second panel has undergone quite a transformation as I felt I could safely commit time to its details at this stage. My process for *Brody's Ghost* involves quite a bit of gray toning done in the computer, so my inks are quite light. I'm not trying to make the image look three-dimensional by way of additional inking—I plan to achieve that in the toning stage.

Note that the lettering is a font. I have my own system of creating the word balloons that involves "sculpting" them in a computer program. I'm very particular about word balloon placement, wanting them to flow in a natural way and obscure as little of the artwork as possible.

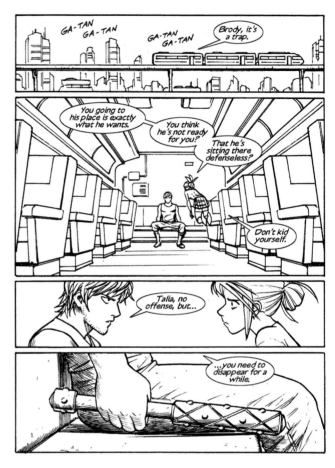

Tones

I complete the page in Photoshop, adding generous amounts of gray tones, as is my style. An artist whose series is meant to look like a made-in-Japan manga would not use this much gray tone and would have the dots composing the gray tone more widely spaced so as to resemble the Japanese processes. *Brody's Ghost* is intended as an American graphic novel series with touches of manga style, and so I allow myself this aspect of individuality in terms of the art.

I have avoided the topic of computer software in this book, since I don't want it to apply only to those who own expensive computer equipment. Rest assured, the most important skills needed in becoming a manga creator are those relating to drawing and storytelling. All the fancy computer software on earth will be of little use to you if you don't master drawing and storytelling first.

Planning a Panel

Laying out an entire page is a complicated process involving many decisions. Let's start with just one panel to examine how those decisions get made.

Any panel you want to do can be executed in any number of ways, depending on the content of the panel and what space is available on the page. Here is one simple panel idea in written form and three different ways it could be carried out.

The Text

Like most panels, this one needs to convey one single moment in the story. I deliberately created a simple moment that requires relatively little of the artist in terms of what the reader needs to be shown.

Vertical Panel

There is nothing in the text that cries out "vertical" or "horizontal" to me. Let's imagine that all the other panels on the page have left me with only a small vertical sliver of space. Showing our character from the waist up helps me fill that space in a way that's natural and pleasing to the eye.

Semi-Horizontal

Maybe I'm left with something somewhat horizontal. In this case, I may move in closer and turn the character to the side so as to fill the space in a more left-to-right fashion.

Irregular Horizontal

Let's say another panel above it has left me with this oddly shaped space that has greater height on the left than the right. I may turn the character to the other side so that all the important visual information—the letter and his facial expression—is on the left.

Multiply this process several times and you'll have an idea of how an artist lays out a full page. Let's stick with individual panels for now though.

Point of View

A manga creator really is like a movie director and cameraman rolled into one. In every panel the place you put the "camera" determines what effect the panel will have on the reader. Here is the same moment in one story presented from four different points of view.

Neutral Staging

Sometimes you simply want to present the reader with some facts in the most direct way possible. By pulling the "camera" over to one side we show the reader everything as if it's on a stage. This panel is remaining quite neutral in terms of what it's telling the reader: "There's a room. There's a butler. There's an old man in a chair reading a newspaper."

Bird's-Eye View

Now we've moved the point of view way up so that we're seeing everything from above. This gives the reader a handy mental map of the location if they need it later on. It is also considerably more dramatic and perhaps a bit ominous. Sometimes an artist will choose this approach merely to liven things up after a series of panels that are quite similar.

Foreground-Background Split #1

The point of view has been shifted to show us the man reading the newspaper close up, leaving the butler at a distance. This panel seems to have a narrative purpose. It tells the reader, "The old man is focused on the newspaper. He is unaware of what the butler is doing." Something about the extreme split of focus creates an atmosphere of unease.

Foreground-Background Split #2

Here is the same technique, deployed in a very different way. We've changed the point of view to show only the butler's hand and the knife he's reaching toward while the old man is left in the background. This one has a clear narrative purpose—it is signals to the reader what is about to happen.

Light and Shadow

Artists have always been fascinated by depicting light and shadow, and manga illustrators are no different. An uninitiated artist may be puzzled as to where all the shading should go. Follow the steps to learn how it's done.

1 Create a Line Drawing
Using what you've learned about drawing a seated character, draw a lines-only picture of a girl seated at a table next to a window. I've made it raining outside to bring in an extra background element you may want to practice.

2 Add Tone
Using pencil, add an even layer of tone to the wall on the right, her hair, her dress, and the picture frame. At this stage there is little sense of light and shadow.

3 Continue Building Dark Tones and Shade the Skin

Go back into the areas of her hair and dress, gradually building up darkness on the left side. Add shading to her skin using a lighter tone, but keep it limited to the left side. We now see clearly that the window is the light source. It is lighting up her right side and leaving her left side in shadow.

4 Continue Shading to Finish

Add extra shading to the wall, table, bench and other objects like the cup and picture frame. Note that the darkest part of the shadow cast on the bench is the area that is closest to her. This is because reflected light illuminates the shadow as it gets farther from her.

Afterword

You practiced the techniques in this lesson using pencil. A manga artist may add the shadows using computer gray tones, marker, watercolor, or any number of other media. But in terms of shadow placement, the same principles apply regardless of the medium you use.

Visit impact-books.com/masteringmanga2 to download a free bonus demonstration.

Composition

If deciding on your panel's point of view turned you into a movie cameraman, then thinking about the panel composition will turn you into a classical painter. Consider the arrangement of the elements within the panel and what will be most visually pleasing.

Here are three panels that contain the same elements: a girl, a boy, a field and a fence. Each employs a different type of composition. All of these compositions work. As an artist, it is your job to choose which composition best suits the moment in the story.

Symmetry

Everything in the panel is perfectly balanced. The boy and the girl occupy similar positions in relation to the left and right edges of the panel. There's nothing wrong with this composition, but it was not meant to be visually exciting. The effect is one of quiet order.

Balanced but Asymmetrical

The use of one-point perspective gives us a sense of depth, but the change of viewpoint also allows us to break up the panel in an interesting way. Pushing the figures way over to one side is a bolder choice than that of dropping them into the exact middle of the frame. The fence balances them out and carves the sky into an interesting shape.

Breaking the Frame

We have moved the girl around so her head and legs are cropped by the frame of the panel. This carves the sky into even more interesting shapes and gives the viewer's eye more to play around with.

Here's another example of the same scene with three different compositions. As you can see, composition and point of view are very closely linked. Changing the point of view always changes the possibilities in terms of the composition.

Symmetry
Once again, everything is right in the middle, and the atmosphere is one of absolute calm.

Unbalanced Asymmetry
Now things are knocked out of balance and the composition becomes more dramatic.

Bird's-Eye Asymmetry
The bird's-eye view allows us to carve up the frame in an interesting way. The audience, stage, and sliver of the balcony each create interesting shapes.

ONE PANEL OR TWO?

Sometimes you have enough space for more than one panel. It's your choice as a storyteller as to which you think is best for that particular moment in the story.

Single Panel
Here we see everything presented to us in a single panel. We shift the character over to one side so as to make a more interesting composition. Otherwise the approach is pretty straightforward.

Two Panels
Here we see the same moment split into two separate panels. By jumping to a close-up just as the character delivers the final line he is made more sinister and the drama is greatly heightened. I don't mean to say that the second approach is always better. Only that it is an option you could consider.

Creating Depth

Not every artist wants his or her illustrations to have a three-dimensional feeling. But if a moment in your story calls for it, you'll want to know how such effects are achieved. Compare these two different versions of the same scene to learn how one was made to convey more of a sense of depth than the other.

Even Distribution of Darks and Lights Will Not Create Much Depth

This panel has been inked in such a way that the tones, attention to detail, and darks and lights are evenly distributed throughout the panel. As a result it all calls the same amount of attention to itself and feels rather flat. I don't mean to say this approach is wrong. Only that it doesn't create a three-dimensional illusion.

Use Darks and Lights to Help Create a Three-Dimensional Effect

Now I have put all the darks into the areas of the panel that are meant to be closer to the viewer. Just as important though is the fact that I have lightened up my approach to the rest of the panel: giving it less detail and creating a bleached-out effect. The figure and the alleyway pop out and come closer to us, while everything on the other side of the street recedes into the distance.

Note that I have achieved this effect without any use of computer gray tones. Many published manga are almost entirely free of such gray tones, so don't despair if you lack access to the computer software that makes such tones possible.

Here we see how point of view can be used to create a
sense of depth, independent of the lights and darks used in
the prior example.

Balanced and Flat

All the objects in the room are laid out from
left to right. Nothing in the frame is near the
viewer. It all becomes rather flat-looking.

Changing the Point of View
Helps Create Depth

Now we have changed our point of view,
bringing the stack of books way up close
to the viewer and creating a number
of "layers" within the frame that go all
the way back to the hallway beyond the
door. In a single bound we have achieved
several things: greater depth, a more
interesting composition, and a sense of
drama that was largely absent from the
first version.

You don't need a room full of objects or a city street to create
depth. Compare these two panels that consist only of three
characters standing next to one another.

Straight Across With No Depth

There's nothing wrong with this panel. Sometimes
this left-to-right arrangement is exactly what you want.
But creating a sense of depth is clearly not its goal.

Layering Adds Depth

By bringing everyone over to the left and layering their
faces one upon the other we gain a much greater feeling
of depth. And, as before, we get an interesting composi-
tion in the process.

Panel Sequences

One you have a handle on how to plan out individual panels, you're ready to move on to storytelling in panel sequences. This is where the real joy of manga creation comes into play. Compare these two different approaches to the same panel sequence to learn how it's done.

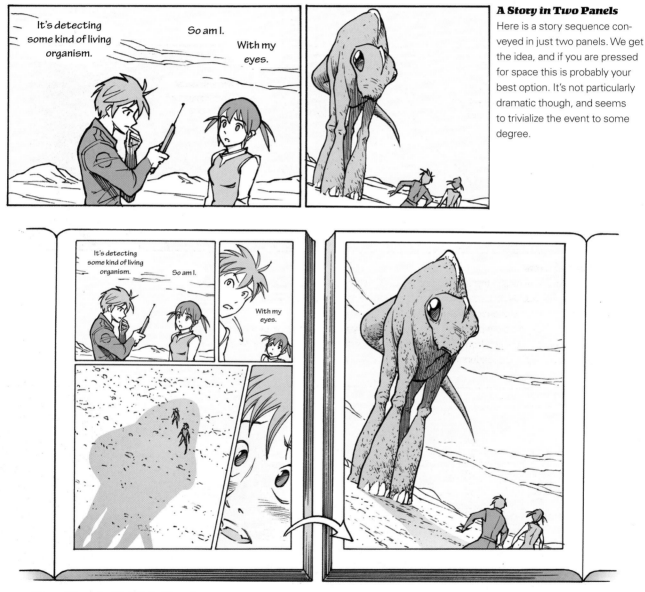

A Story in Two Panels

Here is a story sequence conveyed in just two panels. We get the idea, and if you are pressed for space this is probably your best option. It's not particularly dramatic though, and seems to trivialize the event to some degree.

Same Story in Multiple Panels

The same story is conveyed in five panels. When planning the story you have arranged things so that all of this can fall on a right-side page, keeping the final image hidden from view until the reader turns the page. By adding several more moments to the scene, we build anticipation on the part of the reader. Imagine that you can't see the big pay-off panel. When you see that shadow looming over our heroes in panel 3 you're wondering, "What is it? What does it look like?" Getting that little surprise when you turn the page is one of the great pleasures of reading the story. You don't want to deny your readers that pleasure by letting them see too much too soon.

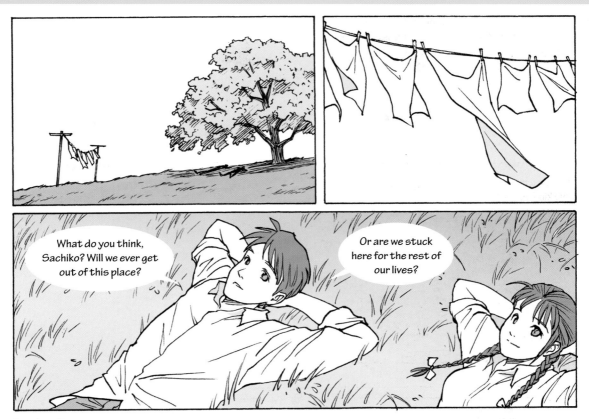

Setting Scene

The first two panels in this sequence are an example of a storytelling technique that the Japanese arguably do better than anyone else. They offer us quiet little glimpses of the world the characters are in prior to having the real scene get underway.

Depending on the type of story you want to tell, you may want to experiment with such panels as you transition from one location to another. It can create an added level of artistry and almost allow the readers to feel that they are really there.

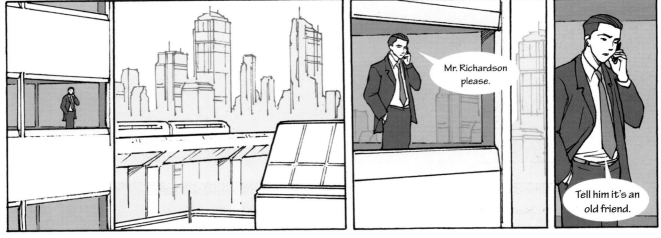

Zooming In

As a manga "cameraman," you may sometimes want to create the effect of the camera gradually zooming in on your subject. Here I chose to start at a great distance before zooming in by degrees to a closer view. By making the character's suit very dark compared to every-thing else, I help the reader's eye find him in each subsequent panel.

Inking Styles

There are so many ways to ink an illustration, and I firmly believe every artist should arrive at his or her own preferred style by way of practice and experimentation.

Here is the same penciled panel inked in three radically different ways. Let this page give you an idea of the various possibilities before you jump in and begin your own journey toward inking mastery.

Pencil

Here is the panel as it looks before inking. Hand it to one hundred different inkers and you will get one hundred different versions.

Minimalist

This less-is-more approach is not concerned with surface detail or the illusion of three-dimensionality. It's more about having a bold sense of design and seeking a clean and understated final result.

Crosshatched

This is probably the closest to my own preferred approach. A gradual build up of lines allows for a sense of light and shadow and a certain amount of solidity. Some of the lines vary a bit in width, and in some places the lines cross over one another to create areas of deep shadow.

Brushed

This approach is rare in published manga. But if you like a bold line you might want to try using a brush and a bottle of ink rather than a pen. An inking master can work wonders with this technique. (Sadly, I am not one of them!)

Layouts

Every page is an arrangement of panels, and different artists have different preferred methods of putting panels together. Here I have taken the same page and laid out the panels two different ways. Compare them to see which approach you'd prefer when laying out one of your own pages.

Traditional Panels

This version uses what might be called the old-fashioned approach—square panels, all in a series of rows. There is nothing wrong with this method. Indeed, some purists feel it is still the best way to do it, and that fancy layouts call too much attention to themselves, distracting from the story.

Non-Traditional Panels

This version allows the character from panel 1 to pop out of the layout and become visible from head to toe. She has no panel. Or is she herself a panel? Depends on how you want to look at it. The whole page becomes much more splashy, and the reader gains a sense of what the character looks like without resorting to an extra-large panel capable of containing her at this size.

The last three panels are not perfect squares—a technique that can heighten the sense of drama or suggest to the reader that the story's calmness is being disrupted.

Making Your Own Panel Sequence

Now it's time to take everything you've learned and put it into practice with a real panel sequence. You're not a beginner anymore, so try to knock this out in just three steps: rough pencils, detailed pencils, then inks.

1 Rough In Your Sequence

Draw two panels. Make the first close to a square and the second larger and more rectangular. In the first panel, draw the rough guidelines of a character's face in the lower left of the panel. This is a confrontation, so use your knowledge of manga facial expressions to make her look angry. In the second panel, draw a close up of the other character with a devious look on her face.

2 Add Detail

Refine the pencil lines. Put extra lines in the hair of both characters and add greater detail to the faces and clothing in both panels.

3 Ink It

Ink the panels and add word balloons with the dialogue of your choice. Let the ink dry, then carefully erase all the pencil lines.

Making the Leap: Full Page Layout

This is it. You're ready to layout an entire page. Again, as an advanced student, try to complete the whole thing in just three steps: rough pencils, detailed pencils, then inks.

2 **Add Detail**
Add details to the various surfaces and indicate the protagonist's facial expressions and the folds of his clothing. Have different ideas of how things should look? Reinvent anything you like to make it your own.

1 **Rough In Your Sequence**
Pencil in four rough panels that fit together to form the page. In panel one we see our protagonist walking through a desolate landscape. In panel two we see a closer view of him, breaking out of the panel if you prefer. Panel three shows a mysterious figure in the foreground calling out to him. In panel four draw a close up of our protagonist turning to see who it is.

Halt!

3 **Ink It**
Ink the panels and add word balloons with the dialogue of your choice. Let the ink dry, then carefully erase all the pencil lines. You've completed a full manga page, start to finish. Don't stop now: Keep the story going!

Conclusion

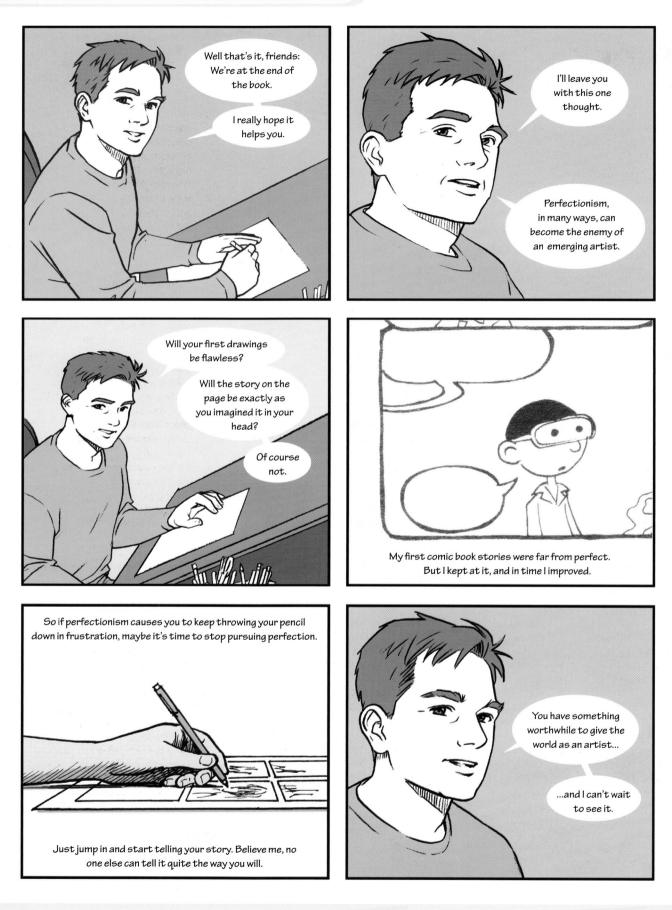

Well that's it, friends: We're at the end of the book.

I really hope it helps you.

I'll leave you with this one thought.

Perfectionism, in many ways, can become the enemy of an emerging artist.

Will your first drawings be flawless?

Will the story on the page be exactly as you imagined it in your head?

Of course not.

My first comic book stories were far from perfect. But I kept at it, and in time I improved.

So if perfectionism causes you to keep throwing your pencil down in frustration, maybe it's time to stop pursuing perfection.

Just jump in and start telling your story. Believe me, no one else can tell it quite the way you will.

You have something worthwhile to give the world as an artist...

...and I can't wait to see it.

Index

About the Author

Mark Crilley is the author of several graphic novel and prose fiction book series, including thirteen-time Eisner nominee *Akiko*, *Billy Clikk, Miki Falls* and *Brody's Ghost*. He is also the author of best selling *Mastering Manga With Mark Crilley* (IMPACT Books, 2012). Since being selected for *Entertainment Weekly's* "It List" in 1998, Crilley has spoken at hundreds of venues throughout the world and become one of YouTube's #1 most-subscribed drawing teachers, creating drawing demonstration videos that have been viewed more than 165 million times. His work has been featured in *USA Today,* the *New York Daily News* and *Disney Adventures* magazine, as well as on CNN Headline News and Comcast On-Demand. Visit his website at markcrilley.com.

Other fine IMPACT Books are available from your favorite bookstore, art supply store or online supplier. Visit our website at fwmedia.com.

17 16 15 14 5 4 3 2

DISTRIBUTED IN CANADA BY FRASER DIRECT
100 Armstrong Avenue
Georgetown, ON, Canada L7G 5S4
Tel: (905) 877-4411

DISTRIBUTED IN THE U.K. AND EUROPE
BY F&W MEDIA INTERNATIONAL LTD
Brunel House, Forde Close, Newton Abbot, TQ12 4PU, UK
Tel: (+44) 1626 323200, Fax: (+44) 1626 323319
Email: enquiries@fwmedia.com

DISTRIBUTED IN AUSTRALIA BY CAPRICORN LINK
P.O. Box 704, S. Windsor NSW, 2756 Australia
Tel: (02) 4560-1600; Fax: (02) 4577-5288
Email: books@capricornlink.com.au

ISBN: 978-1-4403-2830-5

Edited by Christina Richards
Designed by Elyse Schwanke
Production coordinated by Mark Griffin

Metric Conversion Chart

To convert	to	multiply by
Inches	Centimeters	2.54
Centimeters	Inches	0.4
Feet	Centimeters	30.5
Centimeters	Feet	0.03
Yards	Meters	0.9
Meters	Yards	1.1

Ideas. Instruction. Inspiration.

Download a FREE demo at impact-books.com/masteringmanga2.

Check out these **IMPACT** titles at impact-books.com!

IMPACT-BOOKS.COM

▶ Connect with your favorite artists
▶ Get the latest in comic, fantasy and sci-fi art instruction, tips and techniques
▶ Be the first to get special deals on the products you need to improve your art